FIRST STEPS
S E R I E S
Calligraphy

DON MARSH

NORTH LIGHT BOOKS

Cincinnati, Ohio
www.artistsnetwork.com

About the Author

Don Marsh has been a freelance graphic artist and illustrator since 1977, working exclusively as a lettering arts designer since 1980. His work includes posters, commercial and product logos, corporate promotional materials, brochures, signage, point of purchase displays, television and billboard promotions, and business card and stationery design.

Marsh has studied the history and development of letterforms, taking special interest in researching and cataloging the more eccentric forms of the last five hundred years. He has taught calligraphy at the Discovery Center, University of Cincinnati Communiversity, Greater Cincinnati Calligraphers' Guild and at the Cincinnati Civic Garden Center. He has lectured on calligraphy at the Public Library of Cincinnati and Hamilton County and at Northern Kentucky University.

A musician who enjoys fishing and camping, film, model building and anything that has to do with World War II aircraft, Marsh resides in Cincinnati, Ohio.

Calligraphy. Copyright © 1996 by Don Marsh. Manufactured in China. All rights reserved. No part of this book may be reproduced in any form or by any electronic or mechanical means including information storage and retrieval systems without permission in writing from the publisher, except by a reviewer, who may quote brief passages in a review. Published by North Light Books, an imprint of F+W Publications, Inc., 4700 East Galbraith Road, Cincinnati, Ohio 45236. (800) 289-0963. First edition.

Other fine North Light Books are available from your local bookstore, art supply store or direct from the publisher.

10 09 08 07 15 14 13 12

Library of Congress Cataloging-in-Publication Data

Marsh, Don
 Calligraphy / by Don Marsh.
 p. cm.—(First steps series)
 Includes bibliographical references and index.
 ISBN-13: 978-0-89134-666-1 (alk. paper)
 ISBN-10: 0-89134-666-X (alk. paper)
 1. Calligraphy. I. Title. II. Series: First steps series (Cincinnati, Ohio)
Z43.M32 1996 96-4014
745.6'1—dc20 CIP

Edited by Greg Albert
Designed by Brian Roeth
Cover photography by Pamela Monfort Braun/Bronze Photography

"The Family Quilt" (page 6), "We're from the same branch" (page 6), "Children Learn What They Live" (page 8) and "Alphabet Bird Card" (page 9) are used by permission of Anita S. Marks.

"We are here tonight" (page 6), "Congratulations" (page 8) and "Letter to Daniel" (page 9) are used by permission of Wanda Kinzie.

The historic selections on page 61-69 are from *Three Classics of Italian Calligraphy* by Oscar Ogg and are reprinted by permission of Dover Publications, Inc., New York.

"The Colleagues of Calligraphy" (page 114), "Freeman Floral" (page 115), "Delights" (page 115) and "So You're in the Calligraphy Business" (page 115) are used by permission of Martha Ericson.

"The Simplifer" (page 112) used with permission of Karen McMannon.

The text and art in Chapter Four: Projects (pages 78-112) was created by Karen McMannon; the author expresses his sincerest gratitude for her contribution.

METRIC CONVERSION CHART		
TO CONVERT	**TO**	**MULTIPLY BY**
Inches	Centimeters	2.54
Centimeters	Inches	0.4
Feet	Centimeters	30.5
Centimeters	Feet	0.03
Yards	Meters	0.9
Meters	Yards	1.1
Sq. Inches	Sq. Centimeters	6.45
Sq. Centimeters	Sq. Inches	0.16
Sq. Feet	Sq. Meters	0.09
Sq. Meters	Sq. Feet	10.8
Sq. Yards	Sq. Meters	0.8
Sq. Meters	Sq. Yards	1.2
Pounds	Kilograms	0.45
Kilograms	Pounds	2.2
Ounces	Grams	28.4
Grams	Ounces	0.04

Dedication

Dedicated to all those who have labored at the art before me
and have inspired me with their skill.

Acknowledgments

Special thanks to:
Karen McMannon, Martha Ericson, Wanda Kinzie and Anita Marks
For their contributions to this work.

Linda Ipp, Deborah Hastings and Tom Holtkamp
For helping me organize my thoughts.

Greg Albert and everyone at F&W Publications
For giving me the opportunity to share this information.

no. M. Gio...

universale di Questa Illmā. Re...

egne' operationi sali alla altezza del gran

iato, e salitosene' sicome sempre' fatto havea

antissimamete: non doura p cio esser discaro c

accenda quel tanto dilunne' col donargli quest

operetta, quanto con le mie' piccole forze' si

o il maggiore. A dunque' non sdegnate. M

ignore' mio di prendere' questo mio libreto in d

che' picol sia, che al meno e ghe'e p sempre' es

gran testimonio della diuotione' mia uerso di

buona gratia della quall

Table of Contents

Introduction 7

Chapter One
ALL YOU NEED TO GET STARTED 11
All about the materials you need to begin lettering right away.

Chapter Two
BASIC STROKES 23
The basic strokes in the 'a' and 'n' are the keys to your first alphabet.

Chapter Three
EASY-TO-LEARN ALPHABETS 33
Learn the most useful and popular calligraphic alphabets.

Chapter Four
PROJECTS 77
Fifteen calligraphy projects you can do right away to learn the art of fine writing.

Pre-ruled practice pages 116

Recommended reading 120

Sources 120

Glossary 121

Index 125

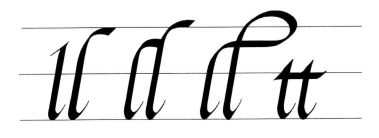

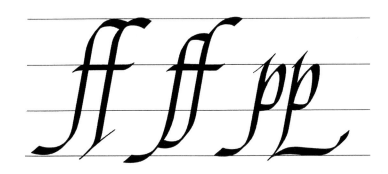

Nothingneß produces white snow;
Quiescence produces yellow sprouts.
The fire warm in the jade furnace,
Over the crucible flies Violet Mist.

We are here tonight
to celebrate the
25th wedding anniversary
of my mother and father

The Family Quilt

The family quilt is made of many pieces
No two are the same, but each
is influenced by those surrounding it.

The pieces are stitched together
with love and tender care,
Binding the old and new
giving the quilt its strength and comfort.

This heirloom of heritage has no end,
only additions to what was before.

We're from the same branch - the same family tree.
Into this world we were born. Call it destiny.
It's Cousin to Cousin - a special bond
a closeness to which we're tied.
You have always been there to laugh with me
and have been there when I've cried.
What a blessing that you were meant to be.
A part of my life, my cousin, you will always
be loved by me.

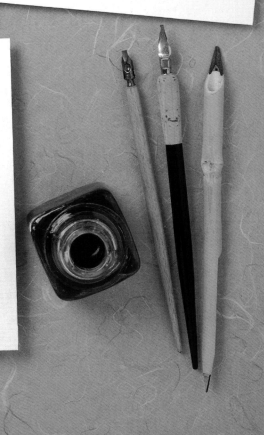

What Is Calligraphy?

Calligraphy, from the Greek: *kalligraphia* literally means "beautiful handwriting." So what is it that makes writing beautiful? Well, in a word: consistency. Consistency of shape, stroke, weight, spacing and rhythm. Although consistency is accomplished through repetition, calligraphy is a not a matter of mechanical repetition.

The subtle nuances of a hand-written text, as opposed to the exact duplication of type, gives it its unique eye-pleasing quality no computer can duplicate.

Calligraphy is as much a matter of seeing as of writing. It is more than simply acquiring a manual skill. You have to train your eye to see the subtle details and propor-

tions of the letterforms.

The hand cannot execute what the mind does not comprehend, and the mind cannot comprehend what the eye does not see. In calligraphy, comprehension comes from being aware of and paying close attention to details.

It is my hope in producing this book that I can assist the student in cultivating this ability to see by making the process easier, more fun and ultimately more rewarding.

This book covers the basics. It will give you a good foundation for a lifetime of discovery and creative satisfaction that the study of calligraphy offers. You will see that just two letterforms, the *a* and the *n,* form the basis for almost all of the

letters in the alphabet. Once mastered, you can build upon them to master several italic styles, or "hands," which are the most useful and popular calligraphic styles.

Even though everyone imitates at first, for this is how we learn, these 'hands' cannot help but slip into our own personal style just as every artist, composer or author has a personal style. This is how it should be. In fact, that is ultimately our goal: To become proficient enough that the art becomes a part of us and that we end up contributing to the art in the process.

Whatever your intentions are in taking up calligraphy, may you find it as rewarding and joyful as I have over the years.

THE TAFT MUSEUM
CINCINNATI, OHIO

Certificate of Achievement

Awarded to

Isaiah White

South Avondale Elementary School

For Outstanding Participation

in the

Images of Kin
Poetry Contest

poet

Michael S Harper

1990 Duncanson Artist-in-Residence

Ruth K. Meyer
Director, Taft Museum

February 24, 1991

Michael S. Harper

Children Learn What They Live

If children live with criticism,
They learn to condemn.

If children live with hostility,
They learn to fight.

If children live with ridicule,
They learn to be shy.

If children live with shame,
They learn to feel guilty.

If children live with tolerance,
They learn to be patient.

If children live with encouragement,
They learn confidence.

If children live with security,
They learn faith.

If children live with fairness,
They learn justice.

If children live with praise,
They learn to appreciate.

If children live with approval,
They learn to like themselves.

If children live with acceptance
and friendship, They learn
to find Love in the world.

CONGRATULATIONS
Congratulations
CONGRATULATIONS CONGRATULATIONS
CONGRATULATIONS
Congratulations CONGRATULATIONS
CONGRATULATIONS
CONGRATULATIONS
CONGRATULATIONS Congratulations
Congratulations
CONGRATULATIONS
CONGRATULATIONS
CONGRATULATIONS CONGRATULATIONS
CONGRATULATIONS
CONGRATULATIONS CONGRATULATIONS
Congratulations

Uses for Calligraphy

People seldom realize just how many uses there are for calligraphy in today's world of ballpoint pens and keyboards. The most obvious use for calligraphy is for correspondence, but its other uses are as unlimited as one's imagination. You can use calligraphy for creating Christmas, birthday and get-well cards; for party invitations and announcements; for fancy labels and tags, posters, flyers, placecards, and all manner of signs and documents. The most common and consistent demands for today's skilled scribe are wedding invitations and certificate design or fill-ins.

Designers use calligraphy in advertising and commercial design to achieve a classic or stylish look or to create a certain atmosphere. Despite the plethora of computer-generated type and letterforms, there is no substitute for handcrafted letters. You'll find them in magazine headings or on billboards, posters, signage, book jackets and wine labels, just to name a few.

Some of today's scribes are reinterpreting the old-world craft of fine handwriting into modern terms and creating one-of-a-kind books which are truly works of art. Other artists are stretching the artistic bounds of calligraphy into exciting new realms of expressionism and abstraction.

How Long Will It Take to Learn?

There is no right answer to this question. Results will vary greatly from student to student, but with a little persistence and consistent effort, you should notice improvements within a very short time. This book is designed to get you practicing in the most effective way by first concentrating on the core shapes of the *a* and *n*.

However you will need to give yourself plenty of time, perhaps a month or even more, before you really start to feel comfortable with the medium. Subtle details take a while to appreciate. Professionals spend a lifetime developing and perfecting their skills, and yet they feel there are always new things to discover and new horizons to explore.

How Much Will It Cost?

Calligraphy is not a costly pursuit. Compared to other art forms, you can accomplish much with surprisingly little in the way of basic supplies. You can get started with an investment of as little as $10. As with anything, though, good tools and supplies can cost much more but are well worth the expense. The serious student should consider spending $20 to $50 to start.

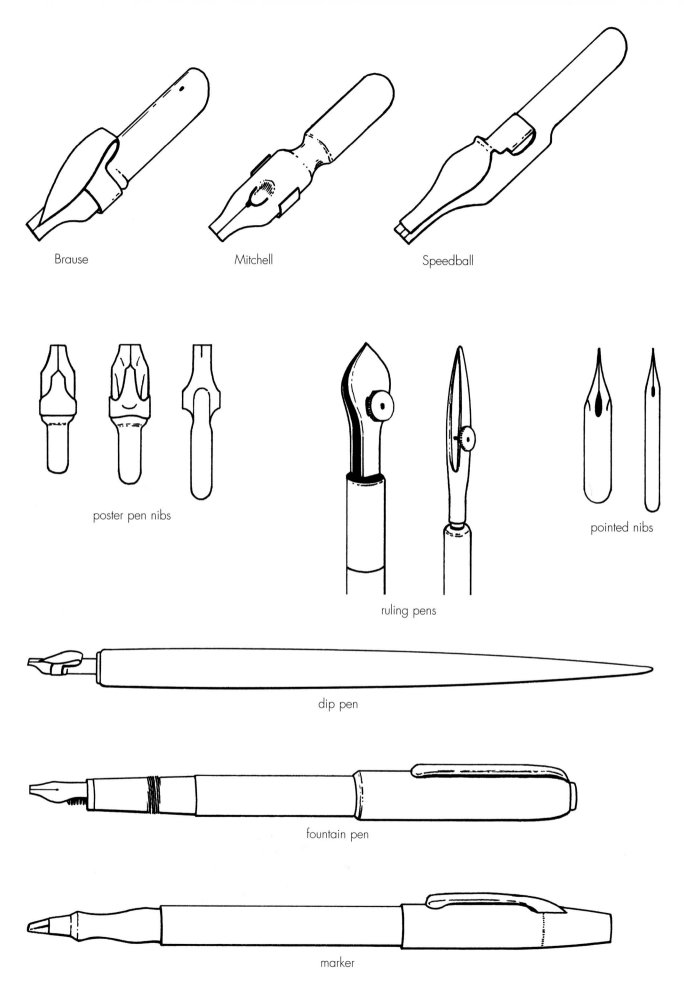

Brause

Mitchell

Speedball

poster pen nibs

ruling pens

pointed nibs

dip pen

fountain pen

marker

Chapter One

ALL YOU NEED TO GET STARTED

The supplies necessary to start learning how to create beautiful writing are simple. Compared to most art forms, calligraphy does not require a lot of expensive, hard-to-use equipment. In fact, all you really need are a pen, ink and paper. Let's start with the pen.

Dip Pen Nibs

The preferred tool of the serious calligrapher is the dip pen, a tool filled with ink by either dipping or loading the reservoir with a brush or dropper. The writing tip, which is inserted into a holder, is called a *nib.* Nibs are available in a variety of sizes and shapes: Edged, spoon-billed, pointed and so on. This book's focus is on the edged pen.

Nibs come in a variety of widths and unfortunately there is no uniform system of labeling nibs. Every manufacturer has its own system for identifying nib size, sometimes assigning a system of arbitrary numbers and/or letters. This can be very confusing for the beginner, even skilled calligraphers find it frustrating. Probably the best system to be implemented is metric identification, e.g., a 2mm is 2 millimeters wide, etc. Sadly, this system is used by only a minority of manufacturers.

Manufacturers

I recommend using a Speedball, Brause or Mitchell nib. Each has strengths and faults, and of course everyone has his or her personal preference. To find yours will be a process of experimentation.

Buying Nibs

When buying nibs, things to watch out for are: uneven or bent tines, separated tines, spurs on the writing edge tip, or any obvious defect in quality. Still you can expect to throw away about one out of every eight or nine nibs you buy because of faults that can't be detected at purchase.

Nib Preparation

A nib must be prepared before it can be used because it has a wax or varnish coating to protect it up until the time you intend to use it. This coating will repel ink and must be removed. This can be done in several ways:

▶ By dropping it in a cup of hot water for a while, then wiping clean.

▶ By dipping the nib in gum arabic then wiping clean.

▶ By dipping it in waterproof ink and wiping it off three or four times.

▶ By sucking on the nib tip for a few minutes, then wiping clean.

Some sources tell you to hold a match under the tip of the nib and burn the coating off. Avoid doing this, as it may warp the tines and ruin the nib.

Cleaning of Tools

Tools cannot be kept too clean, especially pen nibs. You not only want to clean a nib when you are done with it but also often throughout its use. Ink tends to dry after a while causing the capillaries to clog and disrupting ink flow to the tip; drying on the writing edge causes clunky letterforms and hairlines.

When you are completely finished using a nib, you want to clean it as thoroughly as possible. Gently scrub the nib and reservoir with a toothbrush and a little dish detergent and water. Dry thoroughly with a towel.

Nib Holders

A nib holder is the barrel or handle the nib is inserted into. A few good choices are: Koh-I-Noor, with the greatest selection; Brause, a short, all-wood, double-nib holder that can hold a nib at each end; or the Hunt plastic holder, it's the least expensive and easiest to come by.

Nib Size Chart

Pen Width	Speedball	Brause	Mitchell
▬▬▬▬▬	c-0	—	—
▬▬▬▬	—	4mm	0
▬▬▬▬	c-1	3mm	1
▬▬▬	c-2	2½mm	1½
▬▬▬	c-3	2mm	2
▬▬▬	c-4	1½mm	2½
▬▬	c-5	1mm	3
▬▬	c-6	¾	4

Fountain Pens

Fountain pens have the convenience of portability and the luxury of continuous writing. But they are more expensive, about $10 to $70. You are very limited as to the nib selection and the quality and type of medium you can fill them with. The chart on page 16 compares the most popular fountain pens.

Markers

Calligraphic markers are popular and have come a long way over the years. They're excellent for starting out or practice. Nevertheless, most still have drawbacks that make them unsuitable for serious finished work. Markers often have poor writing edge definition, fugitive color and uneven tone. As they wear with use, the quality of the line declines noticeably.

Fun and easy to use, markers are nevertheless very convenient, and you can keep one in your pocket and practice any time, even when writing notes or messages. You will find the broader the tip, the better the performance.

Good markers include Design Calligraphy Art Pens by Eberhard Faber, Speedball Elegant Writer Calligraphy Markers, Sanford Calligraphic Pens and Zig Calligraphy Markers.

New pens appear on the market regularly. They are relatively inexpensive, so there is no reason not to try all of them and find your own favorites.

Nib Pro and Con Chart

Pen Nibs	Pros	Cons	Notes
Speedball, C-series	Excellent ink delivery. Performs well at larger sizes. Easily obtainable.	Poor character definition at small sizes. Uneven quality control. Nibs are long, making it a necessity to hold the pen farther back on the barrel. Reservoir is not removable making cleaning difficult.	A moderately flexible nib.
Brause	Good character definition at small sizes. Predictable performance. Good quality control. Removable, self-positioning reservoir for easy cleaning.	Less than adequate ink delivery at larger sizes. Some scribes think this nib is too stiff to feel "alive."	A very stiff nib; a good choice for writers with a firm hand. Reservoir is on top of nib.
Mitchell Round Hand	Sharp writing edge, producing great character definition at all sizes. Lively and responsive. Good quality control. Removable reservoir (slip on) for easy cleaning.	Can be temperamental. Ink delivery can be erratic. Must tinker with slip-on reservoir to achieve best performance. Must watch overloading with ink more than with Brause or Speedball.	A flexible nib, requiring a light touch. Reservoirs are usually sold separately and slip on the bottom of the nib.
Hiro Tape	Inexpensive, good quality nib.	Not as easily obtainable as Speedball, Brause and Mitchell.	Moderately flexible. Reservoir is similar to Brause design.
Heintze & Blanckertz	Same as Brause.	Ink delivery is identical to Brause. Not as easily obtainable as Speedball, Brause and Mitchell.	Identical in design to Brause but slightly more flexible.

Other Broad Nib Tools

Poster Pens

Other broad-edged tools commonly used are an over-sized type of nib called poster pens. These are used for making letters in a scale larger than the standard large nib, such as for posters or small signs. Many instructors suggest beginners use poster pens when first learning calligraphy because they better enable the student to see the letterforms and to understand how a broad edge works.

Some respected makers of this type of tool are: Coit Pens, Automatic Pens, and Hiro or Mitchell Poster Nibs.

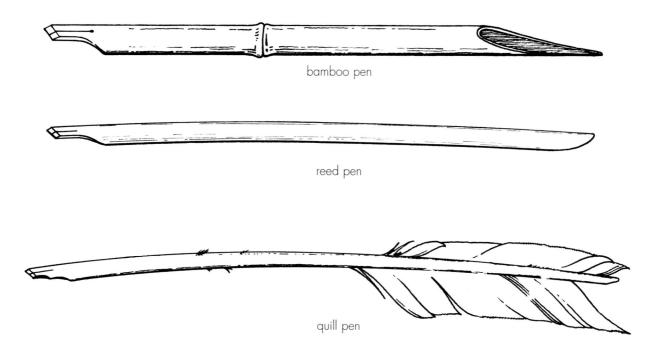

bamboo pen

reed pen

quill pen

Quill and Reed

Calligraphers can also use a quill or reed pen. The quill pen is fashioned from one of the primary feathers of a large bird and once was the most commonly available writing instrument. The reed pen is fashioned from a short section of hollow reed.

Both the quill and the reed pen require careful preparation of the nib, which takes repeated practice to master and is beyond the scope of this book. Both are ancient tools, revered by scribes and rich in tradition.

Additional Tools

An 'HB' or no. 2 lead pencil will be needed to rule your guidelines and margins.

Flat pencils such as one made by Hardmuth or General's are good for roughing-in letterforms to be done with very large nibs or poster pens.

flat pencil

Writing Tools Pro and Con Chart

Writing Tools	Pros	Cons	Notes
Dip Pens	Good variety of nib types and sizes. May be filled with any liquid writing medium.	Takes a bit more effort to learn, control and maintain than marker or fountain pen.	Worth the extra effort to learn and use for the flexibility of writing mediums, applications and quality of results.
Fountain Pens	Convenient, self-contained and portable. Can write without pausing to reload, hence, good for maintaining a rhythm.	Uses limited variety of writing mediums. Seldom colorfast or permanent. Limited variety of nib sizes and types.	Good for practicing or if you want to use calligraphy in your daily writings. Good for cursive italic.
Markers	Inexpensive, convenient and easy to use.	Inaccurate to poor writing edge definition. Dye base so not colorfast. Very limited size and color range.	Good for practicing. Simplicity makes them fun to use but results often lacks appearance of quality.
Reed Pens	Can produce interesting graphic results, especially on textured or watercolor papers.	Can produce uneven results. Requires a lot of care and maintenance. Holds a limited load.	Limited uses.
Quill Pens	Sensual feeling and smooth action. Writing edge can be custom tailored to special requirements.	Difficult to find and prepare. Requires a lot of special care and maintenance.	Writing with a quill produces an interesting psychological connection with and sense of history.

Erasers

Erasers are needed for removing pencil lines and marks. The best is a good nonabrasive white eraser such as Faber Castell's Magic Rub. If you can't find a white eraser, then use an art gum or a kneaded eraser.

Also handy to have in the studio, but not recommended for everyday use, is the Pink Pearl eraser; this is a mildly abrasive eraser like the kind found at the end of a pencil. It is sometimes used for sanding off stubborn stains or errors, but it may ruin the surface of the paper or leave a reddish colored stain.

Ink erasers are very abrasive and should never be used, as they will permanently destroy the writing surface.

Ink

Ink comes in two types: *waterproof,* which will not bleed after it dries, and *washable,* which, being a water base, can bleed after it dries. Both have their advantages and disadvantages (see ink pros and cons chart). Ink also comes in *pigmented* and *non-pigmented.* Non-pigmented ink is a dye base and generally not colorfast, that is, the colors will fade with time and exposure. Pigmented ink on the other hand tends to be more stable and colorfast but should only be used in dip pens.

Ink comes in a variety of colors and categories, such as: India inks, drawing inks and Sumi inks, a high-quality Japanese ink that comes in bottle or stick form (the stick form needs to be prepared by grinding on a suzuri or ink stone). Which ink is right for you is a matter of trial and error. Any major brand of washable ink is satisfactory for starting out or practice.

Inks are transparent and quite often the colors are dull; they should not be mixed.

Watercolors & Gouache

Ink is not the only medium you can use in a dip pen. In many ways gouache and watercolor, in tube

Fountain Pen Pro and Con Chart

Fountain Pens	Pros	Cons	Notes
Platignum	A good quality pen at an affordable price.	Thin lines and crisp edges are adequate.	Standard fountain pen proportions.
Osmiroid	Similar in feel and performance to Platignum but producing slightly crisper lines.	Feels slightly inferior to Platignum in quality.	Standard fountain pen proportions.
Rotring	Good quality control. Smooth writing. Crisp letters. Highest quality ink available in a cartridge pen; black is rich, dense.	Inconsistent ink flow; tends to skip.	Long staff, lightweight.
Sheaffer	Good ink flow. Easy to use. Inexpensive.	Doesn't produce fine hairlines or crisp letters.	Standard fountain pen proportions.
Pelikan	Considered by many to be the best fountain pen available. Smooth writing; produces fine lines.	Expensive. Not always easy to find.	Standard fountain pen proportions.

form, are superior to inks. Where watercolor is a transparent medium, gouache (pronounced *gwash*) is opaque. The advantage of using watercolor or gouache is permanence, vivid colors that may be mixed together to create even more variety, and the fact that they can be made as thick or thin as you want.

They give the greatest range and versatility.

Other Mediums

Other mediums that may be used in a dip pen are: liquid acrylics, dyes and stains. In fact, anything else you can get to flow from the nib could be used.

Actually, many writing fluids being sold as "inks" today are in fact acrylics. Acrylics look and perform very much like ink but tend to dry out in the nib quickly causing clogs. They are water based but waterproof when dry, and their color range is greater and more vivid than ink.

Eraser Pro and Con Chart

Erasers	Pros	Cons	Notes
White Eraser	Nonabrasive, soft and yielding. Least abrasive of all the erasers.	Smears badly if too much graphite accumulates on it or if it gets too dirty.	Your safest and best choice for overall common usage.
Art Gum	Nonabrasive.	Smears badly if too much graphite accumulates on it or if it gets too dirty.	A good second choice if you can't find a white eraser. Smell reminds you of grade school. Fun to crumble.
Kneaded	Nonabrasive, dustless and moldable, like Play-Doh, to adapt to your special needs.	Tends to leave a slight film on writing surface that must be dusted away, or it may affect sharpness of your letterforms.	Although sold as dustless, be aware that it still leaves a slight residue. Fun to play with.
Pink Pearl	Mildly abrasive. Sometimes comes in handy.	Can mar writing surface, must be used with caution. May leave faint red stain.	Good for removing stubborn stains, drips and some errors depending on the quality or type of paper you are using. Not for ordinary usage.
Ink Eraser	None.	Destroys writing surface.	Avoid using.

Other tools

Straight Edges

Straight edges are tools used to make straight lines, such as a ruler, T square or triangles. You will need at least one of these items for ruling your writing surface. Although you don't need them all to start, they work well together to make your task much easier and more accurate.

A T square is only of use if you have a drawing board, preferably with a straight, metal edge.

Triangles, which come in two types, 30 and 45 degrees, work best in combination with each other. They can be used to rule parallel lines quickly by holding one stationary and sliding the other against it.

A ruler is self-explanatory and always handy to have around your work area.

Paper Towels

Some sort of clean-up rag for mopping spills or cleaning nibs is a necessity. Many instructors recommend using a lint-free cloth, but I have found that paper towels work fine and toilet tissue even better because it's the most pliable and absorbent.

Drawing Board

A drawing board is not a necessity, but it makes work a lot more efficient and easier. Although any flat desk or table will do, it is universally recognized that a sloped writing surface will aid you in producing better letterforms.

A sloped surface is more conducive to better work because it allows a better pen angle relative to your writing surface, producing crisper forms. It also places your eyes more directly over your work for a better and more accurate view and prevents you from hunching over your work in a fatiguing posture.

There are a number of relatively inexpensive drawing boards available in art and drafting supply stores, many adjustable to any angle. The degree of inclination can be adjusted to suit your comfort and usually varies from scribe to scribe.

Draftsman's Board Brush

A draftsman's brush is not essential but is very convenient, not only for keeping your drawing board or desk clean, but for brushing eraser dust off your paper without damaging your work.

Light Table

A light table is a real luxury, but it can be a tremendous aid in learning and is almost a necessity if you start doing calligraphy commercially—always an exciting possibility. A light table is simply a box with a translucent (glass or plastic) surface which is illuminated by bulbs in the case below. When turned on, the light enables you to see marks, lines or letterforms through one or two sheets of paper, enabling you to trace over them easily. Light tables come in a variety of sizes. The smaller ones are intended for viewing photographic slides and transparencies. I recommend you acquire one that is at least 11" x 18". Light tables are available from commercial art supply stores and mail order sources.

Storage of Tools

Small plastic containers, such as medicine bottles and the like, make for protective and orderly storage of your various nibs. Also small hardware drawers, such as for nails and screws, make an excellent nib organizer. Be sure that all nibs are completely dry before sealing them in an air-tight container, or they will rust.

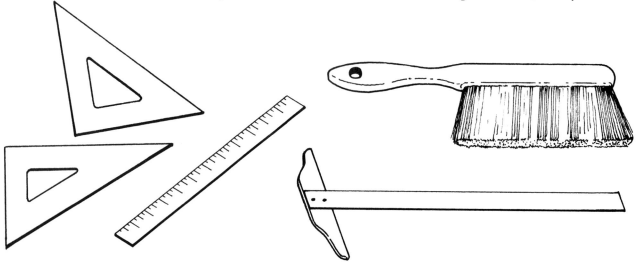

Paper

Calligraphers are always in search of the perfect paper; it's a never ending quest. Paper comes in three types: machine-made, mouldmade and handmade. Most common and commercial papers are machine made and are excellent for most calligraphic purposes. They are easiest to come by and the least expensive, although you will find that good quality paper is not cheap.

Mouldmade paper is made on a machine that mimics the handmade process. This makes for a stronger and often noticeably higher quality of finish, similar to handmade but at less cost.

Handmade paper is actually made by hand, hence it is the most expensive, but many scribes find it worth the expense for that special job. Both handmade and mouldmade papers are most readily available through mail-order sources.

A good, cheap paper to use for practice is ruled loose-leaf paper. Another good choice is a marker layout pad, especially if you are going to use the pre-ruled sheets in the back of this book. Marker layout paper is translucent, so it can be laid over the pre-ruling, and you can see the lines. Also, copier or laser printing paper works well for practicing; just run a bunch of photocopies of the pre-ruled pages in the back of this book and work directly on them.

Paper Finishes

Paper comes in three basic finishes: *smooth*, sometimes called hot pressed because it is pressed between hot rollers in manufacturing; *medium*, sometimes called cold pressed; and *rough*. The smoother the finish, the sharper your letterforms will be. Avoid using a *plate finish*, sometimes referred to as a high finish, as the ink often reacts unpredictably on this very hard surface.

Characteristics of Paper

Rag content refers to the cotton content in the paper, e.g. 25 percent rag means the paper is made of a mixture of 25 percent cotton content.

Waterproof Inks Pro and Con Chart

Waterproof Inks	Pros	Cons	Notes
FW	Very dense blue-black luster. Excellent coverage. Quick drying. Very waterproof.	Dries out quickly in dip pens. Reluctance to flow from nib when starting a character. Clogs nib slits. Obstinate to clean.	Despite drawbacks, I still feel this is the best truly waterproof ink available, especially for brush, ruling pen, crow quill nibs and technical pens.
Calli	Pigmented. Bright colors, fairly opaque.	A little watery. Dull color.	Better selection of colors than most waterproof inks.
Higgins Engrossing	Good flowing.	Tends to bleed.	Unsatisfactory.
Speedball Dense Black India	Good flowing.	Thin and watery.	Adequate. For dip or technical pens.
Dr. Martin's Tech	Very black. Very waterproof.		Popular with graphic artists.

Sizing refers to material such as starch, gelatin, glue, rosin, etc., added to the pulp when the paper is made or applied to the surface after making. This regulates the absorbency of the paper. If the paper doesn't contain enough sizing your writing fluid will bleed into the page. Sizing is usually categorized as heavily sized, moderately sized, lightly sized or waterleaf, meaning no sizing. You will want to stick with heavily to moderately sized paper.

Acidity, or pH, refers to how acidic a paper is. The more neutral the pH, the more permanent your page is. This is not critical at the beginner's stage, but if you want to create something that will last over the years, it must be taken into consideration.

Deckled edge refers to the uneven, feathery edges often found on hand-made papers. This edge is often artificially imitated on mouldmade papers.

Other Vehicles

Other vehicles that can be used include: illustration and watercolor board, papyrus, parchment, and other unique papers such as Japanese papers or paper made from the bark of trees or banana husks.

Washable Inks Pro and Con Chart

Washable Inks	Pros	Cons	Notes
Higgins Eternal	A good flowing, rich black ink. Works well with almost any kind of nib.		A popular and pre-dictable performer for dip pen use.
Pelikan Fount India	A good carbon black ink.	Not as black as one might like.	Works in a dip pen or fountain pen
Pelikan 4001	A very good flowing, high quality dye ink.	A dye base. Watery. Very transparent.	Works best in a fountain pen.
Rotring	High quality pigmented ink. A rich black. Available in more colors than most inks and these colors are mixable. Works better on shiny surface papers than most inks.	Colors are kind of dull.	Not for use in fountain pens.
Sumi Inks	Very dense black. Excellent writing characteristics. High quality.	Will corrode pens. Need to clean pens more often.	A real pleasure to work with. Not for use in fountain pens.

Mediums Pro and Con Chart

Mediums	Pros	Cons	Notes
Ink (washable)	Good flow. Easy clean-up. Easily found and easy to work with.	Watery; uneven color and coverage. Limited color selection. Blacks tend to be more dark gray.	Washable inks are usually not pigmented and so seldom colorfast. Mixing colors is not recommended.
Ink (waterproof)	Very permanent. Very black. Can be worked over with other mediums without bleeding. Richer look than washable.	Tends to dry in and gum-up nibs. Requires frequent nib cleaning and is a bit more stubborn to clean. Some brands are slightly corrosive. Limited color selection.	A good choice for illumination work. Colors should not be mixed.
Sumi Ink	The richest and highest quality of the inks. You control the viscosity and opacity of the mixture.	Not always easy to obtain. Can be expensive. Requires a lot of preparation and a grinding stone. Very corrosive to nibs.	Available in traditional stick form or convenient bottled liquid form. Some sumi inks have a slightly sparkly or iridescent finish. A sensual pleasure to work with.
Gouache (opaque watercolor)	Opaque coverage, rich appearance; most mixable and controllable of all available mediums. Almost unlimited color selection most of which are colorfast and archival.	Requires more frequent nib cleaning than inks.	Pros and cons for watercolors are the same as gouache. A joy to work with. The best medium for color work. Tube form is preferable to cake form.
Acrylics	Mixable and stable brilliant colors; waterbase but dries waterproof. Good color selection.	Requires more frequent nib cleaning than inks.	Transparent. Available in liquid or tube form (liquid form is recommended). A good choice for illumination work when transparency is desired.

Chapter Two

BASIC STROKES

The emphasis of this book is on italic letterforms, both formal and cursive. They are the most popular and useful forms for the beginner.

Formal italic is executed more consciously and precisely, stroke by stroke, using numerous pen lifts. Cursive, while following the same form and proportion, is more spontaneous and casual. It is executed more like common script, with a continuous writing motion and fewer pen lifts.

Writing Position and Surface

Working on a sloped surface, such as a drawing board, is very helpful; you can maintain a comfortable posture, your eyes are positioned more directly over the work for a better view and the pen will be in a much more favorable position to produce crisp letters. If you don't have a drawing board, a table or desk will also work. Some calligraphers use a small, portable board that they rest on their lap and lean up against a desk or table. Moving your chair closer to the table gives the writing surface a steeper angle; sliding back away from the table gives your writing surface less slope.

Concerning writing position, remember what you were taught in elementary school about posture: sit up straight, feet flat on the floor, etc., but relax and be comfortable. Bend at the waist rather than arch your back. Forearms should rest lightly on the top of your writing surface.

Holding the Pen

There is no special way to hold the pen. Hold the calligraphy pen as you would a pencil or any other writing implement: lightly between your thumb and index finger and resting against the first knuckle or your middle finger. Holding the pen too firmly not only restricts fluid movement but causes numb finger tips and writer's cramps.

Loading the Pen

For practice, dipping the pen in the ink bottle is fine. Don't dunk the whole the nib in ink; dip only about one-third of the nib tip into the ink. However, for your fine work, you will get better results if you load the pen with a brush or dropper. The nib will stay much cleaner and will make sharper lines.

To load the nib with a brush, lightly rake an ink-laden brush against the side of the nib's reservoir. To load with a dropper, place less than half a drop directly into the reservoir.

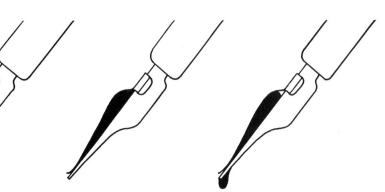

Load pen here with a brush or dropper.

Filling about 2/3 full is perfect.

Avoid: overloading the pen's reservoir; drops and blobs on the tip from overloading; bleed the pen.

The Pen Edge

When you come to understand what kind of marks the edged pen makes and why, the process of using this tool and creating letterforms with it all falls into place. The concept is not as complex as the beginner might think.

The tip of the nib has a width but virtually no thickness (fig. 1). To move the nib along its thin edge produces a thin line, this is called a *hairline stroke* (fig. 2). When you move the nib along its broad edge, it produces a broad line, a mark as wide as the nib is; this is called a *shaded stroke* (fig. 3).

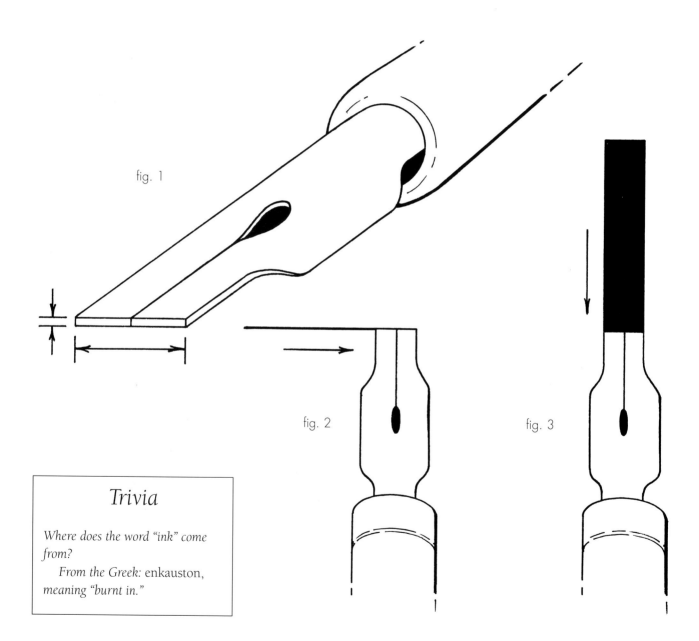

fig. 1

fig. 2

fig. 3

Pen Angle

Pen angle is the angle of the straight edge of the writing tip of the pen, relative to the baseline or horizontal writing lines. This angle is measured in a counter-clockwise direction from the baseline. Each hand has its own pen angle. As you will soon see, maintaining this angle throughout your writing is the trick to working with an edged pen. This consistency is the key to 99 percent of all broad nib calligraphy.

Because of the way the pen tip is shaped, if you maintain a consistent pen angle, the pen will automatically place the thick and thin shades in their proper place. Altering this angle will alter how thick a horizontal stroke is relative to the vertical.

The majority of broad nib hands usually have a pen angle in the range of 20 to 45 degrees. Experiment with moving the pen playfully about on paper while maintaining a consistent pen angle as you move. After you have played with one pen angle, try another. Notice how the weights of your marks change. Pay close attention to the thicks and thins your pen makes.

0 degrees: Pen angle parallel with baseline. The pen's vertical strokes are at their thickest and the horizontal strokes are at their thinnest.

30 degrees: The pen's vertical strokes are almost twice as thick as its horizontal strokes.

45 degrees: The pen's vertical strokes are equal in weight to the horizontal strokes.

60 degrees: The pen's vertical strokes are almost half the weight of the horizontal strokes.

90 degrees: Right angle to baseline: Pen's vertical strokes are at their thinnest while its horizontal strokes are at their thickest.

Using a Double Pencil

A double pencil is a handy home-made tool constructed of two pencils held together with rubber bands. By inserting a spacer, such as a piece of cardboard or kneaded eraser, the scale of your letters can be made larger or smaller. This is an excellent tool for producing large letters in outline. Practice with a double pencil is highly recommended for understanding the principle and function of the broad edge.

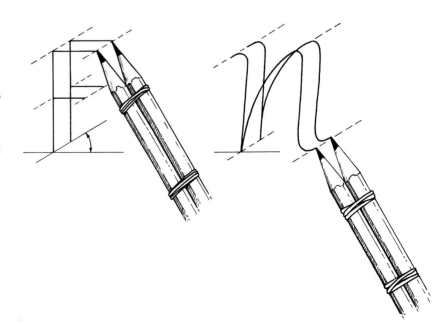

Making Marks

Your first marks should be loose and playful, just getting used to the feel of this new tool. Pay attention to the shapes the writing edge makes, where the thicks and thins are. Small squares, circles, plus signs and *X*s are a good first practice.

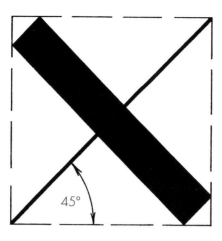

Avoid Rolling the Pen

Don't twirl or roll the pen. Maintain a consistent pen angle throughout. You can check or practice your 45 degree pen angle by making an *X* that fits into a square. The stroke from the upper left to the lower right should be the thickest stroke your pen can make, and the stroke from the upper right to the lower left should be the thinnest stroke your pen can make.

Establish the main vertical stem of each character first then build from that. Construct each character by moving in order from top to bottom and left to right, following the stroke order and direction given in the ductus.

The caps may be executed a bit more loosely and freely than the minuscules, but to quote Fred DaBoll: "Deliberate rather than quick in practice" is sound council.

Favoring the right corner of the nib produces a stroke with a ragged left edge.

Favoring the left corner of the nib produces a stroke with a ragged right edge.

Not rolling the pen to the right or left side and applying even pressure will produce a crisp, stroke.

Anatomy of a Letterform

There are a few basic terms calligraphers use to describe different letterforms.

A *nib-ladder* is a means of measuring letterforms based on the width of the pen nib.

The *baseline* is the line upon which the body of the letter rests.

The *x-height* is the height of the minuscule *x* in that particular hand and is a convenient unit of measure.

The *cap height* is the height of the capital letters.

An *ascender* is a stroke that rises above the x-height. Its upper limit is marked by the *ascender line*.

A *descender* is a stroke that falls below the x-height. Its lower limit is marked by the *descender line*.

Ascenders and descenders are angled to the baseline, usually around 10 degrees to the right.

The character of different lettering styles is largely determined by the relative proportions of these measurements.

nib ladder: 5 pen widths = X-height

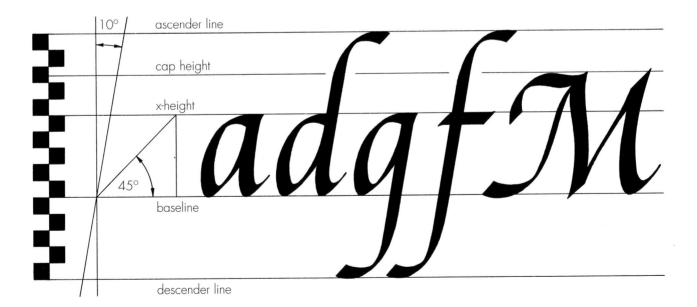

The *A* and the *N*

The italic *a* and the *n* are the two most important letterforms to study in the beginning. The strokes used to create these two letters are used to create twenty-two of the twenty-six letters in the alphabet. Once you have mastered the strokes in the italic *a* and *n*, you can build upon them to master the others.

The italic *a* is made up of four parts done in two strokes. Part one creates the bow. Part two creates the bottom turn. Part three creates the branch. Part four makes the stem.

The italic *n* is also made up of four parts done in one stroke. Part one creates the stem. Part two creates the branch. Part three creates the humped shoulder. Part four makes the right vertical element.

Note the "branching" stroke along with the "humped shoulder," they are the keys to forming the italic alphabet.

Turn this page upside down and you will notice that the bottom of the *a* is basically the same shape as the top of the *n* only reversed; the *n* is basically the same shape as the bottom of the *a* reversed.

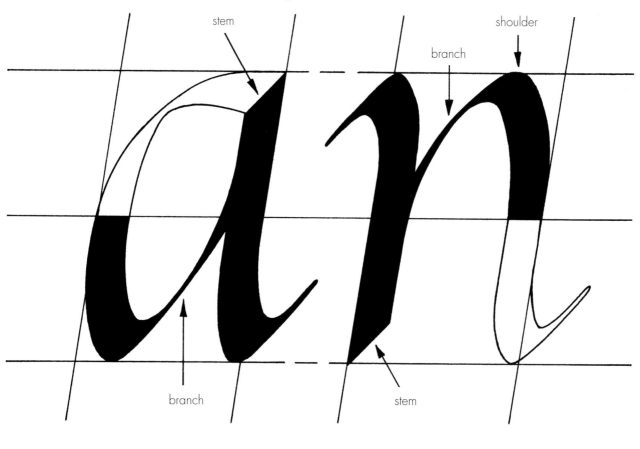

An "alphabet chain" is the alphabet with the letter *n* inserted between each of the letters, e.g., anbncnd... and so on. This has been a recommended method of practice for most hands, especially italic, for more than five hundred years. Begin with a simple practice chain of *a* and *n*; after you feel comfortable with this exercise, start to include the rest of the letters of the alphabet.

On the following pages, we will take a closer look at the basic strokes found in the *a* and the *n*. You will see how only a few basic strokes, as in the *a* and the *n*, form the basis for many of the other letters in the italic alphabet. Once you understand how these strokes compose the various letterforms, you will see why mastering the *a* and the *n* is the key to learning the italic hand, and how learning the italic hand can be the best foundation for your further explorations of the calligraphic art.

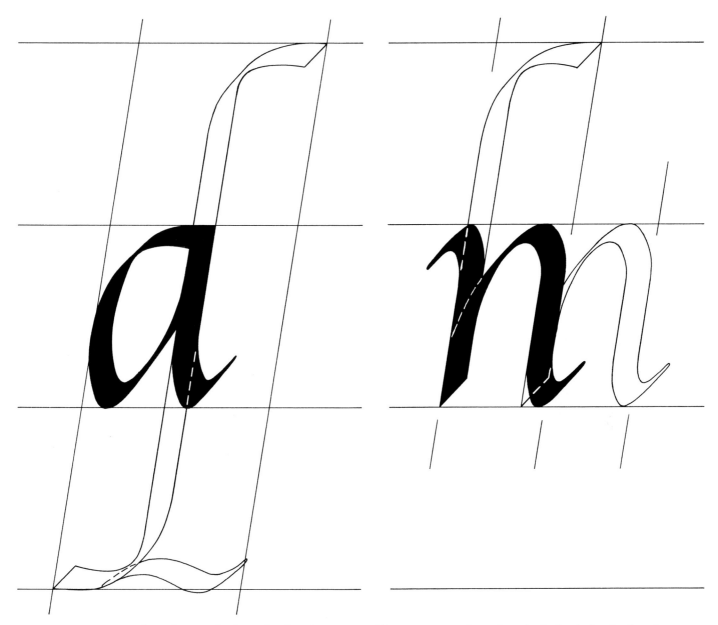

Here we can see how the *a* is the basis for four letters. The *a* forms the body of the *d*, the *d* simply being an *a* with an ascender. Likewise, the *g* and the *q* are *a*s with descenders that differ only in their terminal strokes.

Here we can see how the *n* is the basis for the *h* and the *m*. The *h* is an *n* with the same ascender as we see in the *d*. The *m* is simply the *n* with the shoulder stroke repeated.

In this fascinating example we
see how the *n* is the basis for no less
than five different letters. In the pre-
vious example, we saw how it gen-
erated the *m* and the *h*. Now we add
the *k*, *p* and *r*. The *k* is an *n* with an
ascender and a modified shoulder
stroke. The *p* is an *n* with a descen-
der and a looped bowl. The *r* is an
n with a shortened branch and
shoulder.

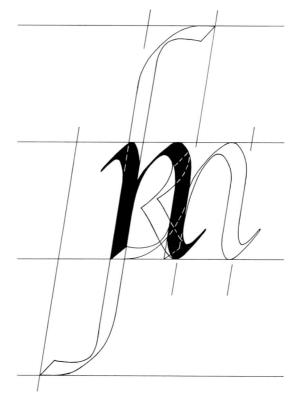

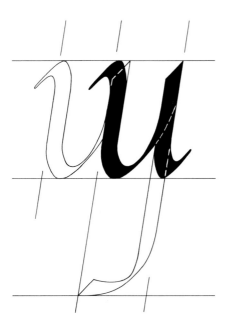

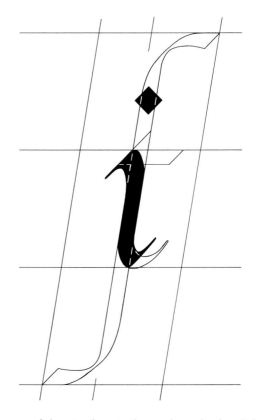

The *a* with an open bowl, or the *n* upside down, is the
core of the letters *u*, *y*, *v* and *w*. The *u* and *v* differ only
with the downward stroke on the right. The *u* becomes
a *y* with the descender added. Link a *v* with the *u* to
form a *w*.

The stem of the *i* is also similar to the *j*, the *l* and the *t*.

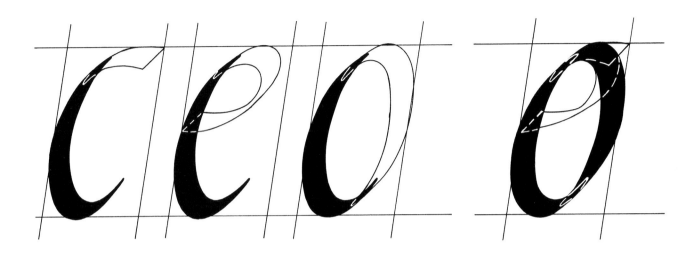

The *c*, *e* and *o*, start with the initial stroke of the bowl of *a*. In fact, that stroke is the *c* letterform. The *e* is that initial stroke that loops tightly back to close. The *o* is composed of two strokes, the second a mirror image of the initial stroke of the *a*.

Trivia

If calligraphy means beautiful handwriting, what is the word for bad handwriting?

Cacography from the Greek: kakosgraphia meaning "bad handwriting."

Consistency of Form

These examples deserve careful scrutiny. Beautiful calligraphy is based on consistency of form. Much of the rhythm evident in the Italic hand is based on the repetition of the same component strokes. If you can master these basic strokes in the *a* and the *n*, rendering them identically, you can then generate almost all the remaining letterforms with eye-pleasing regularity.

The next chapter looks at the italic alphabet in greater detail, but builds on the basic strokes found in the *a* and *n*. As you learn a new alphabet, look for the letterforms' common rudimentary strokes. They form the basis for the unique style and character of that alphabet.

How to Use Ruled Pages

The ruled pages at the back of the book may be used to practice the basic letterforms and alphabets in several ways.

You can place translucent marker layout paper over the ruled pages so the rulings can be seen through the paper; the calligraphy is done on the marker paper without marring the underlying ruled page.

You can also make photocopies of the ruled pages and work directly on the copies.

If you have a light table, most papers can be taped over a ruled page and placed on the light table whereby the ruled lines may be seen through the paper and used as a guide.

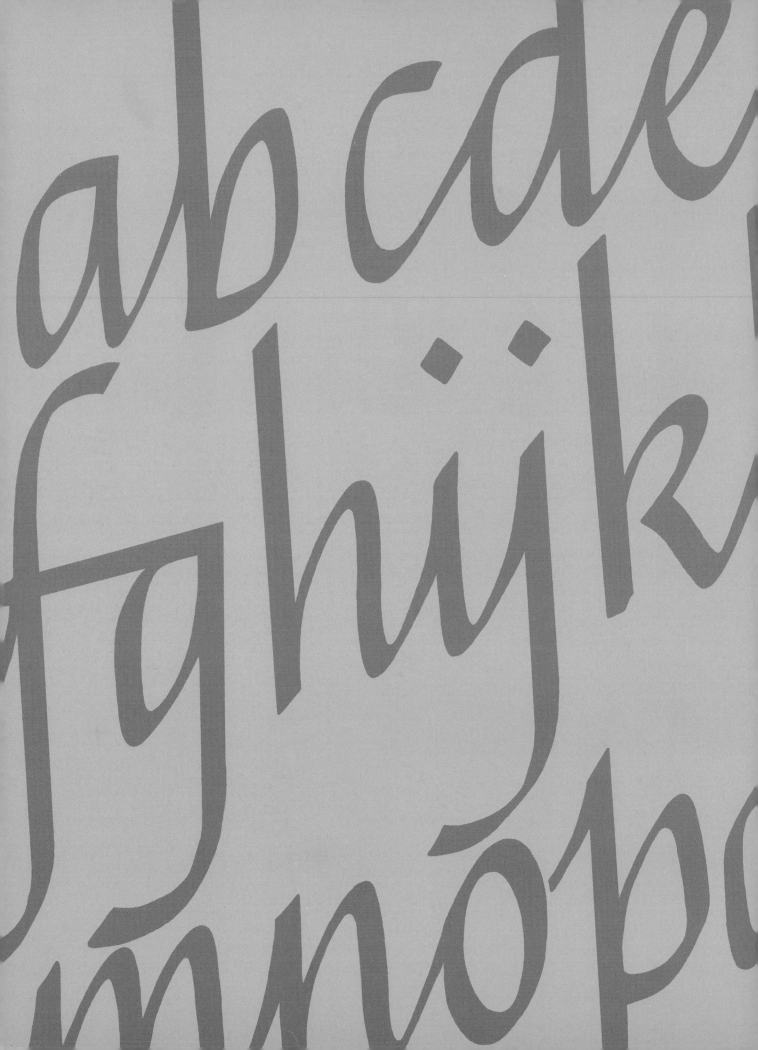

Chapter Three

EASY-TO-LEARN ALPHABETS

Now that you have mastered the *a* and the *n* and have studied how the strokes in these two letters form the basis for most of the letterforms in the italic hand, we can look at several complete alphabets.

Each alphabet is illustrated twice in its entirety. The first sample shows all the letters as they will appear in finished work. On the facing page, each letter is broken down into the individual strokes of which it is made. The numbered arrows indicate the direction of the stroke and the order in which they are drawn. This stroke by stroke pattern is called the *ductus*.

Let's begin with a more thorough look at italic minuscules. Building on what we have learned about the *a* and the *n*, we can examine each letter in turn to learn what strokes are used to create it and in what order those strokes should be made.

Once you are familiar with the italic minuscules and the important details for their creation, you can go on to learn the other alphabets in this chapter. With a little practice, you will be able to simply study the ductus for each letter in the new alphabet and, using the model alphabet pages in front of you as a guide, incorporate the new letterforms in your ever expanding repertoire.

On the opposite page is an example of formal italic by a master calligrapher. Every scribe develops a unique and individual way of forming certain letters, breathing into them their own personality. The important thing is not to strive for a slavish and mechanical imitation of some universally accepted and idealized model, but to work toward the mastery of execution that has an internal consistency, an eye-pleasing rhythm, and a truth to the spirit of the original.

Italic Minuscules

a b c d

e f g h i

j k l m

n o p q r

s t u v

w x y z

Ductus

a b c d

e f g h i

j k l m

n o p q r

s t u v

w x y z

two strokes	*u a*	*a a a a*
three strokes	*b b b*	*b b b b*
two strokes	*c c*	*c c c c*
four strokes	*v o d d*	*d d d d*
two strokes	*c e*	*e e e e*
four strokes	*f f f f*	*f f f f*
three strokes	*g g g*	*g g g g*

u a

Begin *a* slightly below the waist line, pull down to the baseline, make a sharp turn up and to the right touching the waist line, down to the baseline forming the stem, and knife out. Close the top with a fairly flat horizontal stroke.

h b b

The *b* begins like an *h* but closes at the bottom. When turned upside down it forms a *g*.

c c

The *c* starts like an *a* but is made a bit fuller at the bottom.

v o d d

The *d* begins like an *a* without a stem. Add it's top, then make the stem from the ascender line down to the baseline. The stem should attach to the body in the same position as the *a*. Finish by adding its head serif.

c e

The *e* is like a *c* but the second stroke turns in and joins the first stroke at about its midpoint or a bit higher. Don't let the counter close up.

f f f f

The *f* is the only stroke to travel from the ascender line down to the descender line, a long stroke. Don't curve this stroke, keep it straight.

g g g

The *g* is constructed like an *a* but the stem is pulled down into an ascender.

37

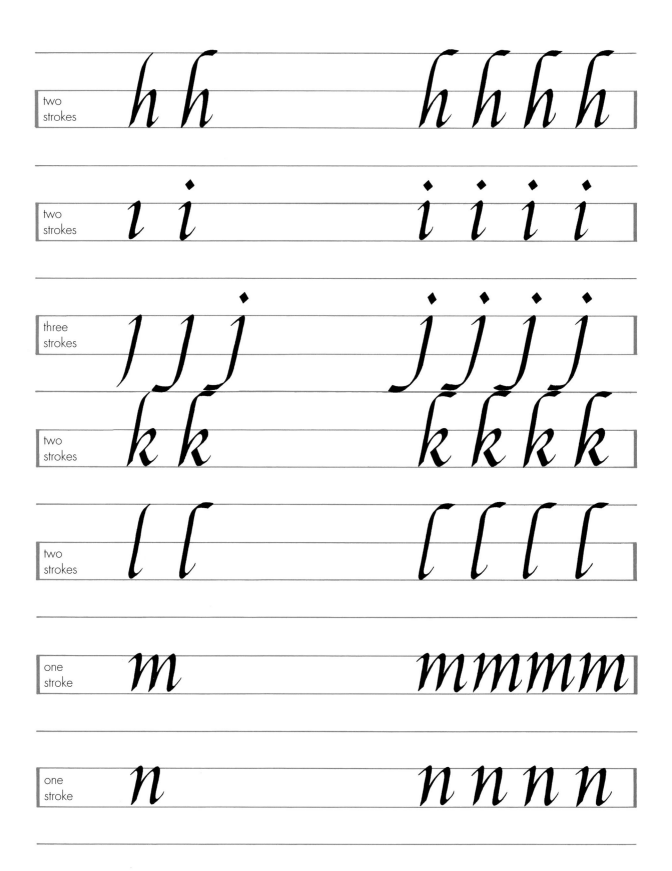

two strokes	h h	h h h h
two strokes	i i	i i i i
three strokes	j j j	j j j j
two strokes	k k	k k k k
two strokes	l l	l l l l
one stroke	m	m m m m
one stroke	n	n n n n

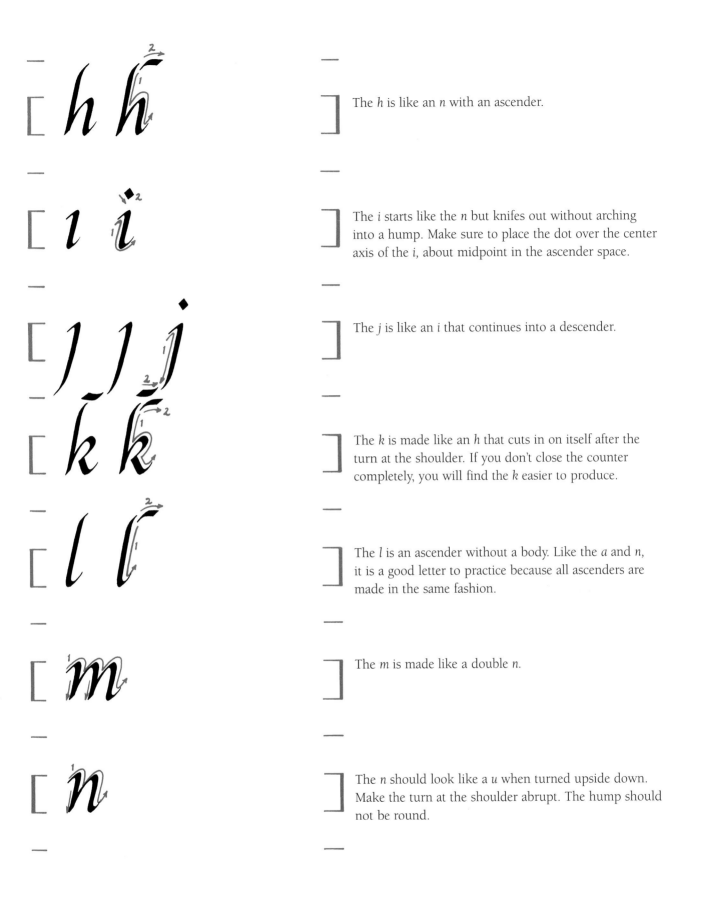

The *h* is like an *n* with an ascender.

The *i* starts like the *n* but knifes out without arching into a hump. Make sure to place the dot over the center axis of the *i*, about midpoint in the ascender space.

The *j* is like an *i* that continues into a descender.

The *k* is made like an *h* that cuts in on itself after the turn at the shoulder. If you don't close the counter completely, you will find the *k* easier to produce.

The *l* is an ascender without a body. Like the *a* and *n*, it is a good letter to practice because all ascenders are made in the same fashion.

The *m* is made like a double *n*.

The *n* should look like a *u* when turned upside down. Make the turn at the shoulder abrupt. The hump should not be round.

two strokes	ı o	o o o o
four strokes	ı ȷ p p	p p p p
two strokes	q q	q q q q
one stroke	r	r r r r
three strokes	s s s	s s s s
two strokes	ı t	t t t t
one stroke	u	u u u u

The first stroke of the *o* is like the first stroke of the *c* or *e* and the second is like an upside-down version of this same stroke.

The *p*, when turned upside down, should look like a *d*; its body is the same shape as an inverted *a*. This letter usually looks better if the top spikes up slightly like the top of a *t*.

The *q* is executed like a *g* but its tail breaks in the opposite direction.

The *r* is done as if doing an *n*, but don't branch it from the stem as wide, and at what would be the shoulder turn, the stroke finishes out much like the second stroke of the *c*.

The *s*, to many, is the most difficult letter to master because its spine is unlike any other alphabetic shape. The key to this letter is the spine; don't make it too curvy.

The *t* begins just below the waistline and swings or knifes up to spike just above the waistline. Pull the stroke down straight and make the turn at the baseline like the exit of the *c*.

The *u* is like an upside down *n*.

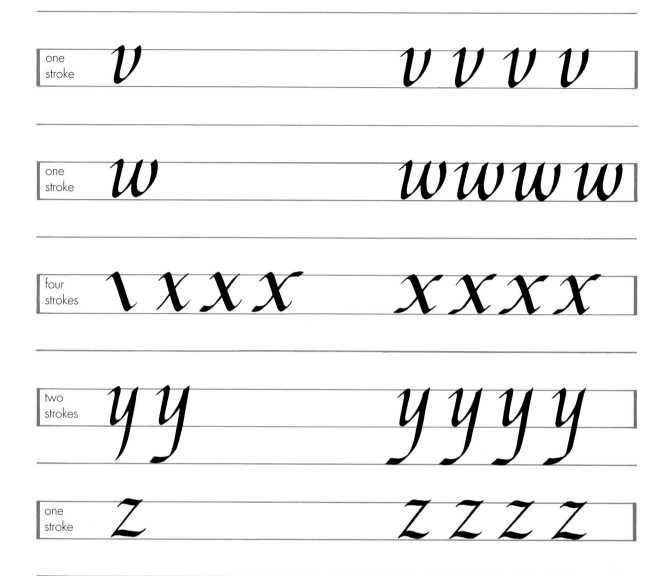

one stroke	*v*	*v v v v*
one stroke	*w*	*w w w w*
four strokes	*\ x x x*	*x x x x*
two strokes	*y y*	*y y y y*
one stroke	*z*	*z z z z*

Trivia

Did you know that if you are right-handed you are dextral, and if you are left-handed you are sinistral?

The prejudice against left-handedness is even inherent in our language. People who are good with their hands are called "dexterous," meaning the right side; while the word "sinistral" (left side) was the "dark side" like in Star Wars, giving us words like sinister.

Trivia

Did you know that Z was originally the sixth letter of the alphabet?

It was dropped by the Romans thinking they didn't need it. When it was readopted, it lost its place in line and so moved to the end of the line.

v

The v is done like a u without a stem but its final part bows out a little more. This character may be done in one stroke or two if you find that pulling the final stroke gives you better control or ink flow.

w

The w is like a double u but the character's form seems more pleasing if you make the second part a little rounder at its base. It can be done in one stroke, or two if you find that pulling the final stroke gives you better control.

v x x x

The x is best practiced by drawing them in a series of parallelograms. Make sure the second stroke crosses the first at the center.

y y

The y when turned upside down looks like an h. Its body is executed like a u that pulls down into a descender.

z

The z is a fairly simple character to produce. Make the top stroke somewhat flat and the bottom a bit fuller.

Trivia

Did you know that when you see "Ye old..." the "Y" is really a "Th"?

The letter was called "Thorn" and stood for the compound letter "Th," similar to the Runic character "thorn," Hebrew "teth," Greek "theta," and Arabic "zal." So "Ye" was just a short hand version of "The."

Trivia

Did you know that for a period of time the Greeks and Romans wrote in alternating directions?

This was called boustrophedon from the Greek meaning: "ox-turning," i.e., in the same pattern as an ox was used to plow a field.

Double Letters

Some letters frequently appear doubled, such as: *tt, ll, ff* and *pp.* These letters are often *ligatured,* that is, joined together; but you have to be careful not to confuse their legibility. Double letters also offer an excellent opportunity to be playful and lend interest to the page. Here are a few basic rules and examples for handling double letters.

▶ If you tie *tt* or *ff* together at the crossbar, don't join them at their base.

▶ With ascenders, staggering them works best, making the first character a bit shorter than usual and the second a little taller.

▶ Pairs often become more legible, even when executed at the same height, if you use two distinctly different styles of entrance and exit strokes on the ascenders and descenders.

▶ If you have the space, the ascender or descender of the first character may be looped into the following character.

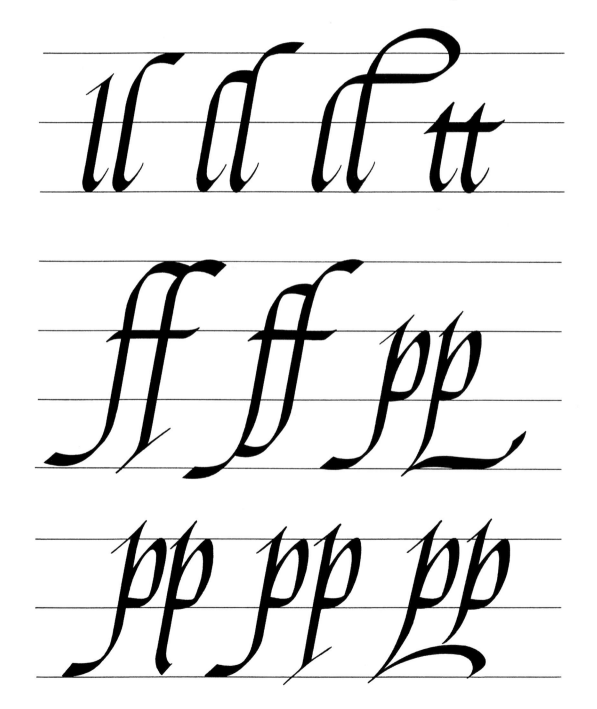

"Looped g" in Detail

One of the more complex but beautiful letterforms is the "looped g," also referred to as a "linked g." It is a character that lends itself well to swashing.

The body of the g is like a minuscule *o* only done at approximately ⅘ of the x-height. Note, it does not sit on the baseline. The link and arm are done much like the spine of the majuscule *S*. The bottom is fuller than the top with the overall form fitting into a sloping, conical shape. The body's oval shape being vertical while the lower loop's oval shape is somewhat more horizontal.

Here are the "looped g" parts and proportions.

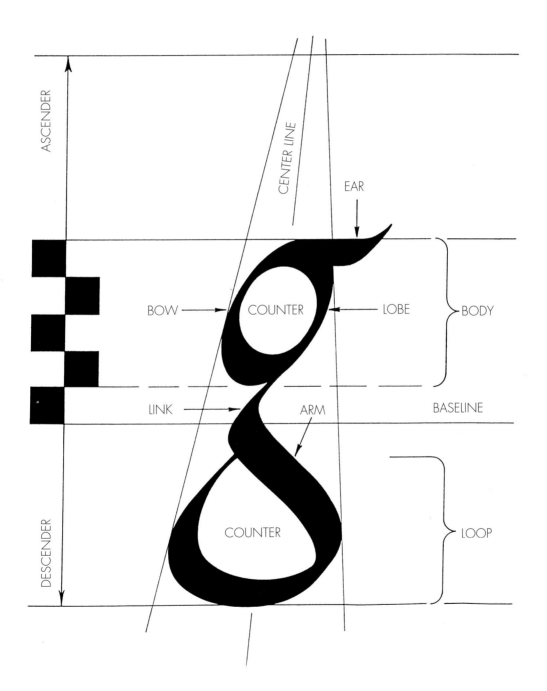

The *S* in Detail

The *s* can be a difficult character to make at first because it is the only letter where its main stroke is a compound curve, cutting back in the opposite direction from which it starts. This is called an *ogee curve,* it forms the spine of the *s.*

Note how the form of the *s* fits comfortably into an *o,* but the top and bottom parts flatten out a bit more to keep the counters open.

The bottom of the *s* should be slightly fuller than the top.

A good practice for establishing the proper shape and balance for the spine of the *s* is to do a row of *o*s, then go back and execute the spine of the *s* in each of the *o*s, as shown in the center illustration. This works for the capitals as well as minuscules.

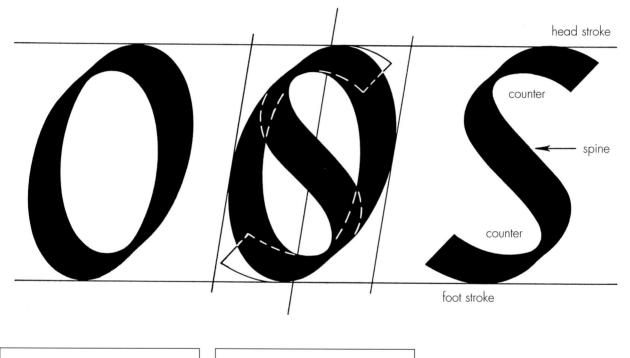

head stroke

counter

spine

counter

foot stroke

The *T* in Detail

The drawing of the *t* in detail illustrates its parts and the subtle shape and form of the character. Since the *t* is a relatively simple letter to construct and there are so many slight variations that have evolved over the years, it is important to pay close attention to its subtleties, whichever form you use.

The shaded area at the top of the *t* is called the triangle and is the most complex part of the character. The cross bar always extends more to the right than the left and is placed as if glued to the bottom of the waistline in all of its forms. Make sure the stem is straight and not bowed. The exit turn at the base is done similarly to the exit shape of the *e* and *c*.

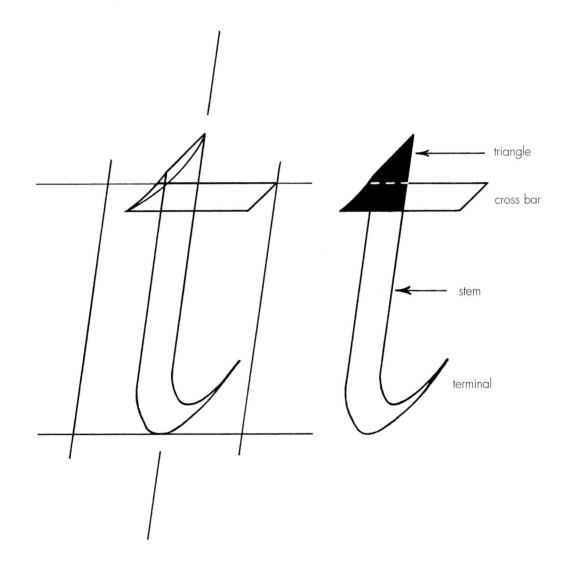

triangle

cross bar

stem

terminal

Alternate Letterforms

The characters shown below may be used in place of those previously demonstrated. If you should choose to use any of the alternative letters, pick one variant and use it consistently. Do not mix a variety of the same character.

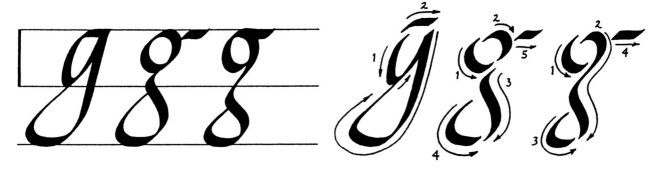

This *d* works best as a final, i.e., the last letter of a word or sentence.

This type of *q* may be used at anytime as long as the tail doesn't conflict with other descenders.

This *k* has an arm rather than a bowl so its counter is open.

The first *g* is made as previously shown but the descender is made in one stroke connecting back with the body.

The second and third versions are linked *g*s with subtle ear, link and arm differences.

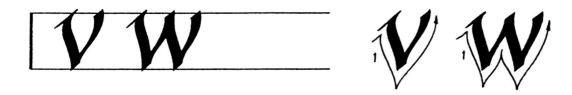

The *v* and *w* shown here are pointed versions more commonly found historically. They may be done in two strokes but are more often executed in one. Note the subtlety in their shaping.

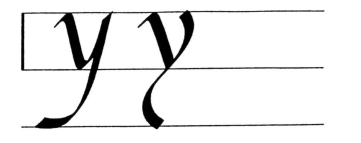

The first *y* is done much like that previously shown, only the first and second strokes are not parallel.

The second version is a graceful old-style, two-stroke *y*.

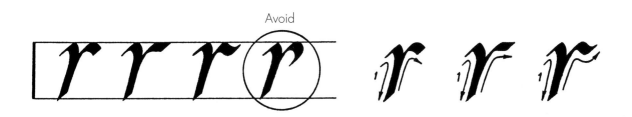

The first *t* is very similar to the one used throughout this book, except that when started, the pen doesn't swing up to the apex, but "knifes" straight along the nib's edge before pulling down into the stem.

The second *t* is a simple, old-style cruciform version.

The first *e* is made as shown earlier, and the swash pushes up out of the letter or can be pulled down by creating the character in three strokes.

This second *e*, done in three strokes, has a high cross bar that is done fairly flat. Be careful not to let the counter close in on this version.

Avoid

The first *r* shown here is the same as throughout this book and given for comparison.

The second has a flag that runs flat under the waistline.

The third *r* has a flag with a slight wave in its shape.

Avoid making an *r* with a "wilted" flag.

Simple Roman Caps

Majuscule letters (capital letters or caps) are where the greatest liberties have been permitted historically, and so several historic forms are included in this book. Many calligraphers prefer to use simple Roman caps instead of the purely italic. Which form you use is a matter of personal choice.

Simple Roman

A B C D

E F G H I

J K L M N

O P Q R S

T U V W

X Y Z

Ductus

A B C D
E F G H I
J K L M N
O P Q R S
T U V W
X Y Z

Simple Italic Caps

The degree of difficulty in executing the majuscules increases a bit more as you move from simple Roman caps to italic and on to Swash Italic. Pay close attention to maintaining a consistent slant to the letters.

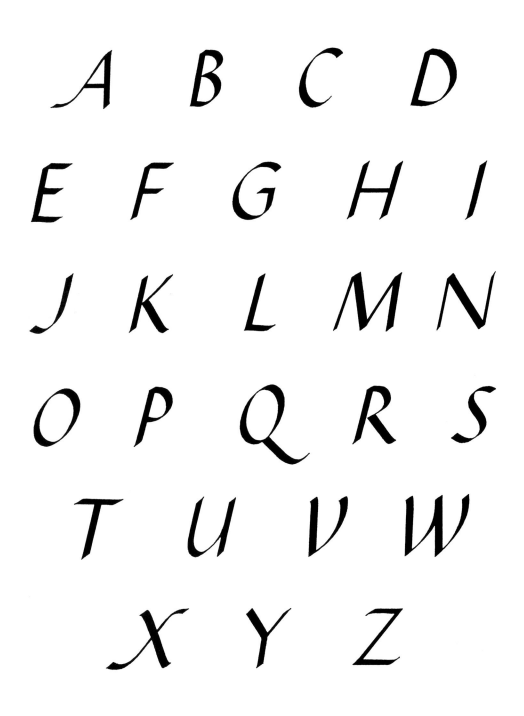

Simple Italic

A B C D

E F G H I

J K L M N

O P Q R S

T U V W

X Y Z

Ductus

A B C D

E F G H I

J K L M N

O P Q R S

T U V W

X Y Z

Swash Caps

Swash capitals form the most decorative alphabet in this book and require care and attention to detail to master. Used with moderation, they add flair and color to your work. They should never be used to write an entire word.

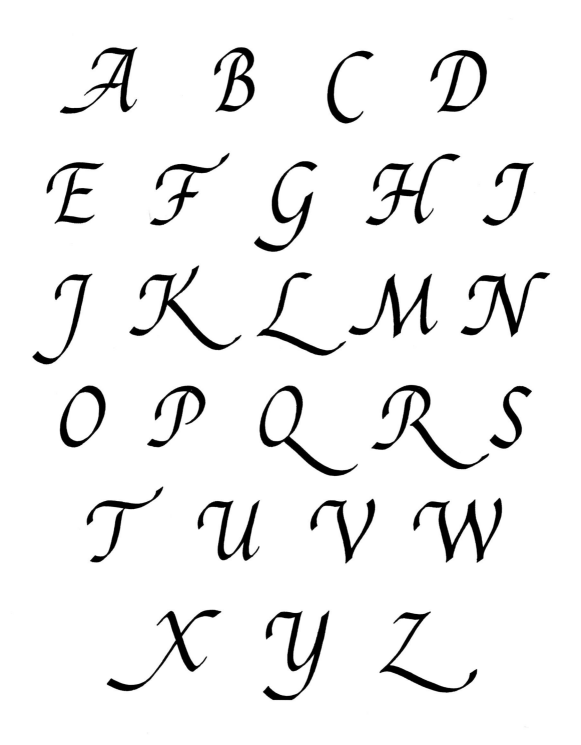

Ductus

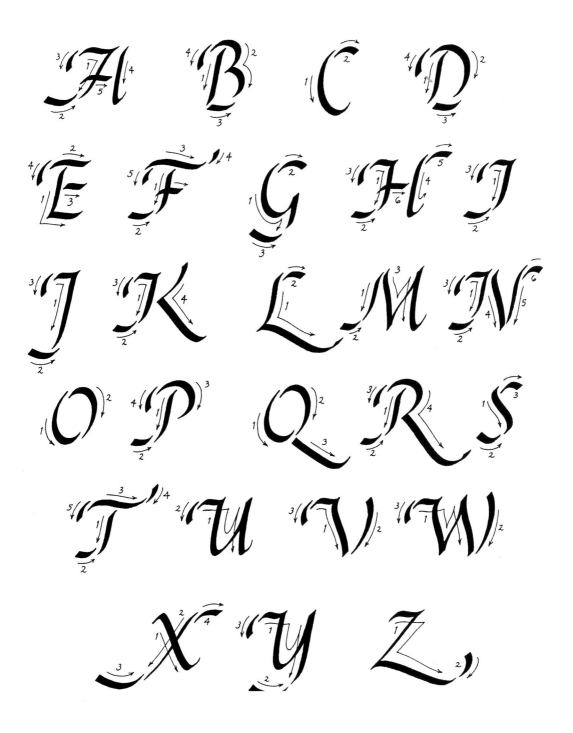

Swash Letters

Swash characters are letterforms where one or more strokes are extended beyond the essential basic form for decorative purposes. Although more common in capitals, swash characters may be capital or lowercase letters. They are used to dress-up a page, lend visual interest, impact or an air of elegance.

However, in calligraphy, swash letters are useful in other practical ways, too: Helping a brief quote fill a space so it doesn't "swim" on the page; extending a short line; or "justifying" copy, that is, making the lines in the text line up evenly at the left and right margins.

Many beginners tend to overdo it when it comes to swashes. This is understandable when you consider that these fancy and playful forms are probably what attract many to calligraphy to begin with. So it is with some reluctance that I include this information in a beginner's book because swashes should be used sparingly, and one must have a competent hand before attempting swash forms. I cannot stress this strongly enough.

When creating swashes, as with everything else in calligraphy, educating the eye to details and appropriateness is the key to creating good forms. Studying the works of the original "writing masters" of the fourteenth century and the works of diverse respected modern calligraphers is not merely invaluable but essential.

Lightly swashed

Moderately swashed

Heavily swashed

Swash has developed into an elaborate flourish

Swashing minuscules usually works best when pulled into a spacious margin, such as an ascender of a first line into the top margin (fig. 1); a descender of a last line into the bottom margin (fig. 2); or used to extend a short line by drawing out an element of a final character (fig. 3).

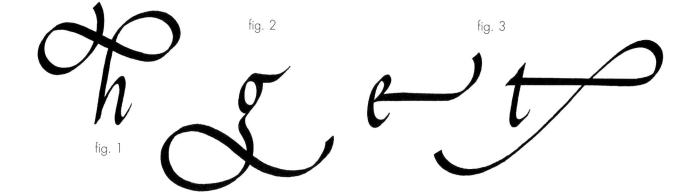

fig. 2

fig. 3

fig. 1

56

Arrighi's Caps

I've taken the liberty of separating some of the various versions of majuscules from Arrighi's writing manual of 1522 into three basic categories. The first version is the most simple, a slab serif roman. The second version, a bit more complex, is a simple swashed italic. The third version is the most elaborate, being an exuberantly executed swash form common during the fourteenth century.

At the time, there was no difference between the characters *I* and *J* or between the characters *U* and *V*, and the character *W* was rare. In the first version, I've added my own *J* and *W*. In the two more elaborate versions, *I* and *J* are interchangeable, as is *V* for *U*.

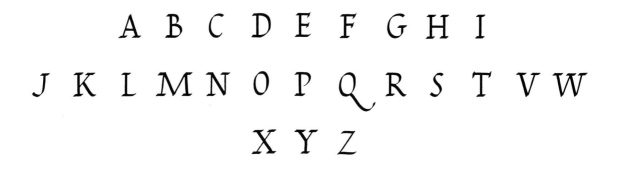

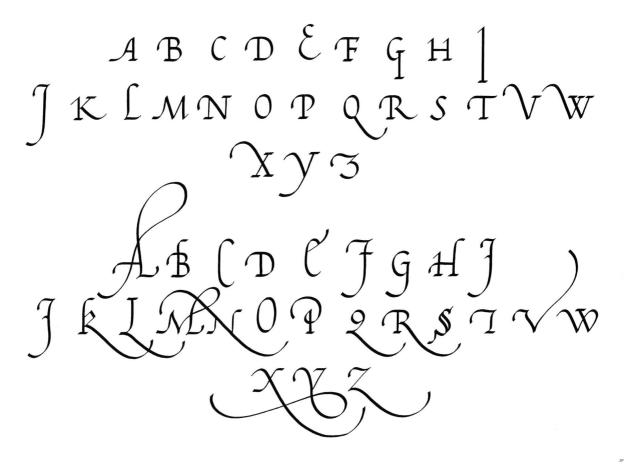

Serifs

Serifs are the finishing marks found on the ends of the strokes of a character. Different types of serifs used on the same letterform can produce alphabets with very different looks and personalities. Letterforms not having serifs are known as sans serif. Be consistent, don't mix and match, use the same style of serif throughout. Here are a few common types:

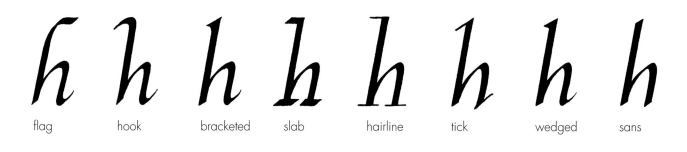

flag hook bracketed slab hairline tick wedged sans

Ampersands

An ampersand, also known as an "and sign," is a ligatured and usually stylized form of *et*, Latin for "and." Ampersands can lend an interesting flourish to a page or be used to conserve writing space since it can be done in half the space of the word *and*. Ampersands sit on the baseline and are executed at cap height, not ascender height.

Here are four versions and their ductus:

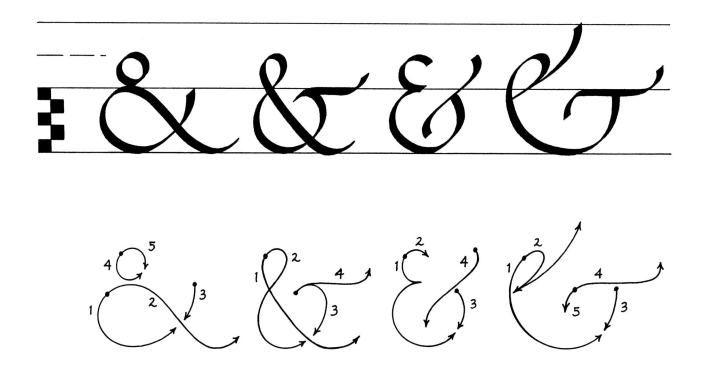

58

Numerals

Numerals come in two forms: "modern," also known as "line numerals," or "non-ranging."

Many people make the error of using only one style all the time, but each has its appropriate use. If your page is to contain a lot of numbers or lists of numbers, such as a phone list, then modern style is your best choice; they appear more consistent and orderly and are easier to read. If your page is to contain only a few numbers then old style is your best choice. The reason for this is that their staggered format will allow them to blend in better with the ascender/descender pattern of the body writing, and your numbers will not stand out like a sore thumb.

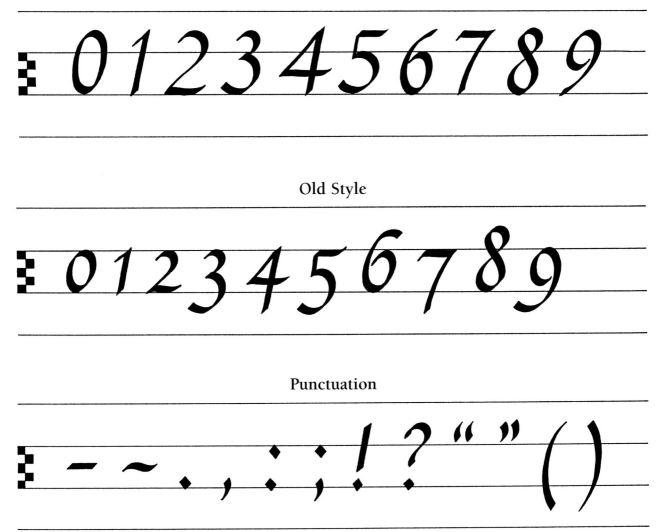

Modern

0 1 2 3 4 5 6 7 8 9

Old Style

0 1 2 3 4 5 6 7 8 9

Punctuation

- ~ . , : ; ! ? " " ()

Cursive Italic

Cursive italic, also called "informal italic" or "running hand italic" is done in a fashion similar to common handwriting, with as few pen lifts as necessary but still following the italic form; whereas "formal italic" is more controlled, deliberate and utilizes extensive pen lifts.

Evolving from the historic "Chancery cursive," this sans serif version lends itself to quicker execution, but tends to lack the elegance and readability of the formal italic. Many people use it for their common handwriting, and it makes for great rhythmic practice. Use simple italic caps with this hand.

On the following pages are excerpts from books by three of the greatest masters of the italic style. These three treatises comprise what most calligraphic historians consider to be the most important historic sources of the italic form.

The copy book of Arrighi, a writing master in Venice and later a scribe for the Roman Curia, was the first illustrated book of the italic letterform when it was published in 1522. It was followed in 1524 by a copy book by Tagliente, the outstanding writing master of his century. Palatino, considered to be the greatest of the three, published his book in 1540.

The study of these works is both fascinating and instructive for beginners and masters alike. The examples presented here amply embody a sense of history and demonstrate the evolution that has led to today's forms. They show how the guiding principles have remained consistent over the last five hundred years. They are also excellent examples of page layout and classical form.

These works also demonstrate how different styles can be due to the idiosyncrasies of each scribe, while still obviously falling into the category of italic form. This should be reassuring to all calligraphers, especially beginners, since we all have our own personal style. Mastering the form is the goal, rather than achieving a generic italic hand. A page of majuscules, minuscules and text form of each of the three writing masters is shown here.

These excerpts were taken from the highly recommended reprint of these treatises, *Three Classics of Italian Calligraphy: An Unabridged Reissue of the Writing Books of Arrighi, Tagliente and Palatino* compiled by Oscar Ogg and published by Dover Publications, Inc.

abcdefghijklmno
pqrstuvwxyz

These letters join with an upward sloping hair line to any following letter:

adhiklmnu

The letters with a cross bar join at the waist line. Do not connect them at the base line also:

fa ff fi fm fn fo fr fu fy ta te ti tm tn to tr tt tu tx ty

These combinations may be swash ligatured:

st sp ct st sp ct

These letters do not join with any letters that follow them:

b g j o p q r v w x y z

Vtra le' retro=
scritte' cinque' littere' a c d g q
ti fo intendere'
che' anchora quasi tutte' le' altre' lre'
se' hanno á formare' in questo :: qua=
dretto oblungo et non quadro per
fetto □
perche' alocchio mio la littera
corsiua ouero Cancellarescha
vuole hauere'
del
lungo &' non del rotondo: che' rotonda
ti veneria fatta quá=
do dal quadro
perfetto
&' non oblungo la formasti

A A B B C D D E E F
G G H H I K K L L M M
M M N O O P P Q
R R S S T T V V V V
X X Y Y Z Z & & &cet

~: Ludouicus Vicentin. Scribebat :~
✛ Rome anno domini ✛
• MDXXII •

A a b c d e m f m g m h i k l m n o p q r s t u m x m x y z •
• w •

∴: Deo optimo & Immortali auspice :∼

A a b c d e e f g g h i k l m n o p q r s s t u x x
x y x y z z e̅ & T

Cosi ua il stato human: Chi questa sera Finisce
il corso suo, Chi diman nasce. Sol
virtu doma Morte horrida
, e, altera .

Ludo . Vice̅ timus Rome in Parhione
Scribeba T .

· A N N · M D X X I I ·

Deo, & Virtuti omnia debent ,

Io te notifico discretto lettore come inanci che insegni

le regule, ragione, mesure, modi, dignitate & ex.tie

di questa nobile uirtute del scriuere io uoglio seguire

de scriuere di molte uarie sorte de litere per satisfare

a gli uarij appititi digli homeni per che a cui e grato

una sorte a cui unaltra & poi seguedo

daroti lo amaustramento che cum facilita

le potrai imparare

con le sue mesure etarte come seguendo uederai facedoti

asapere

il

nome di questa litera essere chiamata cancellaresca

comuna .

a aa bbb. ccc. ddd. eee. fff. ggg. hhh.
iij. kkk. lll. m m m. nnn. ooo ppp. qqq.
rr R. ss. ss. tt. st. uu. uuij. xx. yy. zz & &

Eccellentissimo. M. Giouanni padre uro siete illustre,
col fauore uniuersale di Questa Ill.ma Republica
p le sue degne operationi sali alla altezza delgran.
secretariato, e salito sene sicome sempre fatto haueu,
uisse santissimamete: non doura p cio esser discaro che
io gli accenda quel tanto dilume col donargli questa
mia operetta, quanto con le mie piccole forze si e po-
tuto il maggiore. A dunque non sdegnate. Magnifico
signore mio di prendere questo mio libreto in dono, come
che picol sia, che al meno e glie e p sempre essere al modo
gran testimonio della diuotione mia uerso di uostra Ma-
gnificentia. Alla buona gratia della qualle humilmete
niu Ricomando.

Aaa. bb. cc. dd. ee. ff. ff. g g. hh. ij. kk. ll. mm. nn.
.oo. pp. gg. rr. ss. ss. ss. tt. tt. st. uu. xx. yy. zz. & &.

A uolere' imparare' regolarmente' questa
Eccellente' virtu de lo Scriuere',
Qual si uoglia Sorte' di
lettere', è necessa-
rio

primieramente' sapere' tenere' ben la penna
in mano,
Senza la quale' auuertenza, è impossibi-
le' peruenire' alla uera perfettione' de lo
Scriuere'.
Et però auuertitite chela penna si
deue' tenere' con le due' prime'
ditu appoggiandole' so-
pra'l terzo,
Perche' tenendola altrimenti, Il tratto no
uerria sicuro, ma
tremolante',

Per formare la lettera . a . si deue inco-
minciare dal tratto Testa ⌐ & ritornádo
legiermente tirare in giù el tratto Imuer-
so . r . Poi co'l taglio sallire à trouare la
testa ⌐ & di nuouo co'l trauerso calare
in giù . a . Lasciandoli nel fine un poco
di taglietto . a . quale serue per ligamēto
et congiuntione di l'una lettera con l'altra,
Dandoli la sua tondezza & gratia, se-
condo uedrete nelli essempi.

⌐ r o a a a a a a a a

La lettera . b . si principia similmente co'l
Tratto testa ⌐ & calando co'l trauerso
. l . poi ritornádo in sù con un taglietto ⌐

Maiuscole Cancellaresche.

A A A B B C C D D E E E

F F F G G H H H I J K K L L

L L M M N N O O P P P

R R S S T T V V V X X X

Y Z Z & & & & E.

&

Johannes Baptista Palatinus Ciuis Roma.

Scribeba F.

The Parts of a Page

Illustrated below are the parts of a page presented in the form of a two page spread. Most of the terminology is the same as for a single-page design.

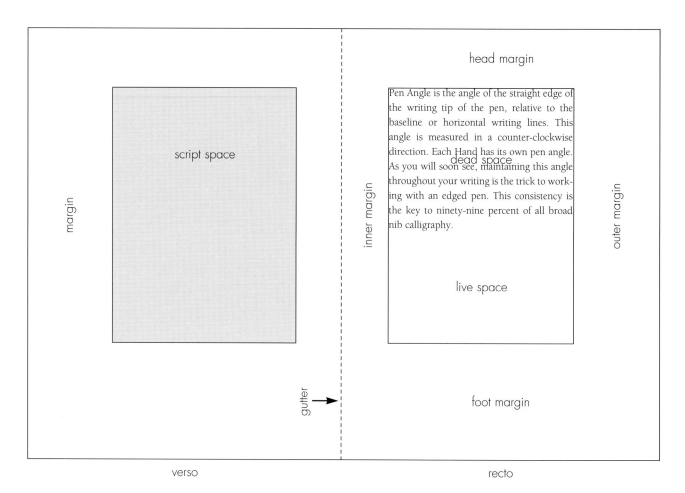

head margin

script space

margin

inner margin

outer margin

dead space

Pen Angle is the angle of the straight edge of the writing tip of the pen, relative to the baseline or horizontal writing lines. This angle is measured in a counter-clockwise direction. Each Hand has its own pen angle. As you will soon see, maintaining this angle throughout your writing is the trick to working with an edged pen. This consistency is the key to ninety-nine percent of all broad nib calligraphy.

live space

gutter →

foot margin

verso recto

margin: The outside space around a body of copy, occurring in four types.

head or top margin: The space at the top of a page, above a body of copy.

foot or bottom margin: The space at the bottom of a page, below a body of copy.

inner margin: The space between the gutter and a body of copy, in a spread or book.

outer margin: The space between the body of copy and the outer edge, in a spread or book. On a single page layout, the inner and outer margins are just called the left and right side margins.

script space: The space designated to be written in.

live space: The script space not yet written in.

dead space: The script space that has already been written in.

gutter: The area of a book or spread where the inner margins of facing pages join.

recto: The right hand page in a book or spread, which is always an odd numbered page.

verso: The left hand page in a book or spread, which always bares an even numbered page.

Margins

Margins are the empty space surrounding the script space or body of text. The matter of establishing margins is more a matter of personal taste than of set rules. The key to creating good margins is to have a logical relationship between all the inherent proportions, but the final arbiter is your eye.

Margins too small will appear crowded, cramped and forced.

Margins too large will give the appearance of copy "swimming" or lost on the page.

Margins just right. A page with comfortable balance between text and space.

Based on the Johnstonian ratio, 2:2½:4.

A few standard proportion formulas have come into common usage over the years, and the principle for each is basically the same. Measure the longer edge of the paper and divide this by a simple fraction to give you a constant basic unit of measure. Most commonly, the longer edge of the page is divided by fifteen or sixteen for a larger margin, and nineteen or twenty for a smaller margin, to produce a unit of measure. Now use the measure of two of these units at the top of the page, 2½ on the left and right sides, and four at the bottom to establish your margins. This is called the Johnstonian ratio, after Edward Johnston, the calligrapher and teacher credited with the revival of calligraphy in the twentieth century.

Here is a rather extensive list of some of the more often used margin "unit ratios." The first three in the list seem to be the most common.

Top		Sides		Bottom
2	:	2½	:	4
2	:	3	:	4
2	:	2	:	4
2	:	2	:	3
1½	:	2	:	3
2	:	3	:	5

Layout

Layout is the design and organization of a page. It is always a good idea to do a few test sketches, called "thumbnail" sketches. These are just small, rough doodles to establish basic page concept. Once you have a definite direction, do a scale mock-up page, called a "dummy," to work out any design problems before you try to do finished art. This takes the guess work out of executing a finished page by providing you with a blueprint to follow.

Formal

Formal
Formal layouts are based on a center line with centered text and arrangement.

On the left is an example of centered copy, rag left and right.

The example on the right is centered and flush left and right.

Informal

Informal
Informal layouts are based on an asymmetrical reference line.

The example on the left uses a vertical reference line to the left of the center of the page from which it keys its lines.

The example on the right uses a line of reference off-set to the right.

A page of copy that favors one side of the page more than the other, such as flush left, rag right, is also an informal layout.

Static Dynamic

Here are two opposite extremes:

A static layout implies business and formality. But a page that is too static will have no life, movement or personality.

A dynamic layout implies a party, action and excitement. But if a page is too dynamic, it may be alive, but it will appear too busy and random, confusing the eye. Strive for balance and happy medium in your work.

Alignment

Alignment is how the lines are placed on the page. What type of alignment you choose will contribute to whether the page has a formal or informal appearance.

There are five basic types of alignment. Centered and justified are formal choices. Flush left, ragged right can be used to give a formal or informal presentation and is a safe choice, as is centered, when you are not quite sure which to use. Flush right, ragged left and asymmetrical layouts are considered informal alignments.

Centered

Justified

Flush left, ragged right

1. Centered is where each line keys off a center line. A pleasing arrangement and one of the most useful and common calligraphic choices.

2. Justified, also known as flush left and right, is where the lines are aligned on both the left and right.

3. Flush left, ragged right is where the left side is aligned while the right side is unjustified. This is how people commonly write and how type often appears in books.

Flush right, ragged left

Asymmetrical

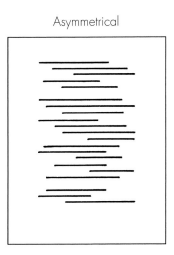

4. Flush right, ragged left is the opposite of number 3. Not a common arrangement due to the fact that it makes for difficult reading and is best used only for short pieces and specialty applications.

5. Asymmetrical looks the easiest and most spontaneous, when in fact it is the most difficult arrangement, involving many sketches and experiments to obtain pleasing results.

Multiple Columns

You can use multiple columns in your layout to produce a more interesting page design or to organize information into sections for greater clarity or impact. Sometimes it is the only way to handle a large volume of copy that must be contained on a single page. A multiple column arrangement can also make for easier readability since the eye doesn't have to travel as far to take in a line.

Illustrated below are a few ideas for two- and three-column designs and some of their variants.

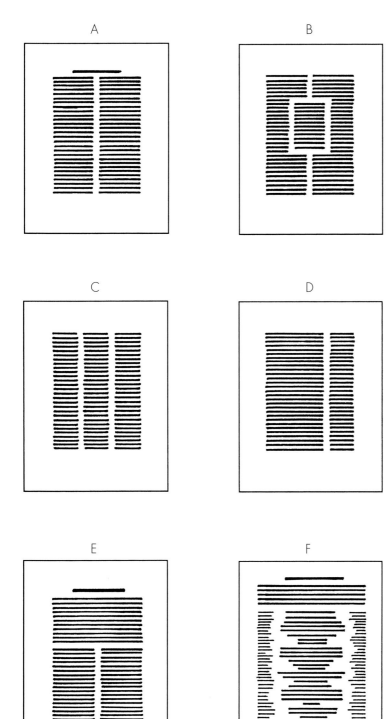

A. This is a simple two-column format. If a title is to be used it should be centered.

B. This is a variant of a two-column design with an inset box. The text of the two columns "wraps" around the centered box. This works especially well if the text in the center of the box is done in a different weight, size or style than the text in the outer columns.

C. This is a three-column format. Titles usually work best when centered in this format.

D. This is a two-column design done over three-column grid. Using this same concept, the large and small script spaces may be ordered in reverse. This type of layout will usually optically balance better if the text in the larger space is done smaller than the text in the smaller space.

E. & F. These are complex combinations of several format design choices.

E. A single body of copy followed by a doublecolumn works fine, but a double column followed by a single is confusing because the eye doesn't know which box of copy to go to next.

F. This is based on a three-column grid, but the center column is ragged left and right and centered, the left column is flush left, ragged right and the right column just the reverse. Center column text should be larger or bolder than outer columns.

Line Length and Centering

Line length will vary based on the aesthetic results one is striving for and the space with which one has to work. Figure out which line of text will be the longest and write it out on a test sheet with the pen you intend to use. Measure this line and you will know the minimum width of writing space you will need. You can vary line length by trying different nib sizes, altering letter size. If necessary, you can slightly change the spacing between letters and words to adjust line length. If a line needs to be extended, you may want to use extended letter swashes or flourishes at the end of the line.

As for centering, there are several ways by which you can center lines of copy. Here are a few methods commonly used.

Method	Pros	Cons
1. Pencil in a vertical center line; lightly pencil each of the lines into place, then ink over. When dry, carefully erase out the pencil.	Quick and simple when used on short pieces.	Involves a trial and error process that may involve several attempts, so not a good choice for longer pieces.
2. Do a scale mock-up using the same nib you intend to use on the finish. Then with scissors or an X-Acto knife, cut out each line as close to the lettering as possible. Fold each strip so that the first and last letters cover each other. Where the fold occurs is the line's center. On the paper that finished work is to be done, lightly rule in a vertical center line. Line the fold mark up with the page's center line and tape just above the writing line. Do finished writing just below cut out strip guides, following as closely as possible the word and letter spacing on the strip above.	A tried-and-true easy method that gives you the opportunity to shift the lines around and view for best positioning first; for this reason, it is the best choice for asymmetrical layouts also. This method allows for rhythm and spontaneity on the finished piece.	A tedious and messy procedure, but there is no getting around it. Also, it is easy to stray from the exact positioning of your example strip, so proceed cautiously.
3. Use a light box, or if you don't have access to one, use a glass table top with a light under it. Write out the lines, measure to find the center of each and mark the centers. Rule a vertical center line on the page where finished work is to be done and place over the first version. Place on the light table and line up the center lines to ink a line at a time.	Simple, accurate and convenient.	You have to have a light box. Can be very fatiguing on the eyes. Be careful that your overlays don't shift on you while working; lines can end up askew.
4. If this is not a one-off original piece, the easiest method is to do a "paste up" to make photocopies or a printing plate. Do your finished work on one page then cut out lines as in method 2. Measure and mark the centers of each line. Align each strip with the vertical center line on a second page, pasting each into place. You now have a camera-ready page for photocopying.	A very accurate process, it allows for a lot of tweaking, corrections and modifications.	A messy procedure and you won't want to show anyone your original paste-up.

Chapter Four

PROJECTS

The following projects serve two purposes: The first is to provide exercises to copy for practice; the second is to provide models of practical applications of calligraphy.

Practice is essential. Calligraphic skills can only be acquired or improved through diligent practice. However, this practice can be fun and practical. It doesn't have to be boring or tedious.

I recommend you complete the exercises in the previous chapter before using these projects. I suggest you do them in the order presented, because they are arranged from simple to more complex. However, if you are too eager to wait, you can start with any of the projects and try your hand at it. If you aren't immediately satisfied with your results, you can turn to the alphabet in the previous chapter and practice those letter-forms with which you need help.

These projects are also examples of practical uses of calligraphy. Besides giving you ideas of where and how to apply your developing calligraphic skills, these models can be readily copied as is.

There is no need to copy these models slavishly. Feel free to make your own elegant variations of the prototypes here. In time, as your skill and confidence grows, you will be able to dispense with them altogether.

Project One
DAYS OF THE WEEK

This is the first of fifteen projects designed to familiarize you with common applications of italic calligraphy. The left page illustrates what you achieve. The ductus page on the right shows how you can achieve it by using horizontal lines to indicate the height and alignment of letters, lines to guide your writing slope, and arrows to indicate pen movement.

This project, shown here reduced in size, was written with the C-3 nib.

Monday

Tuesday

Wednesday

Thursday

Friday

Saturday

Sunday

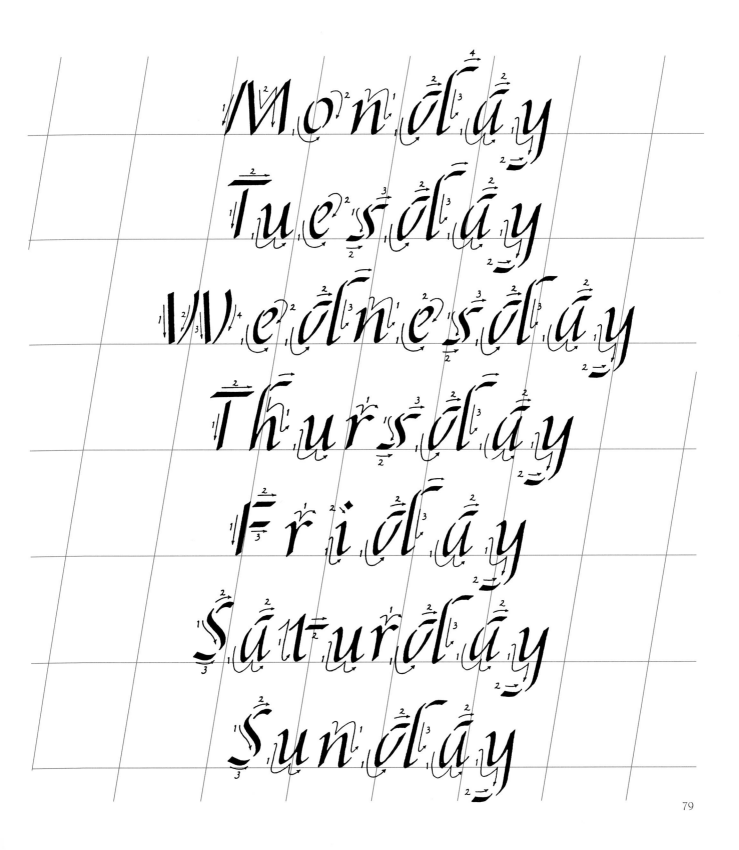

Monday
Tuesday
Wednesday
Thursday
Friday
Saturday
Sunday

Project Two
MONTHS OF THE YEAR

As you strive to develop your lettering skill, you will find yourself writing the same letterform over and over again. Your practice will be more beneficial if you keep a good model within your eyes' view, compare your letter to the example and ask yourself how it can be improved before you write it again. Feel free to smile at your successes.

The months of the year were written with a C-3 nib but are shown here in a reduced size.

"Practice does not make perfect. Perfect practice makes perfect."
—Vince Lombardi.

January

February

March

April

May

June

July

August

September

October

November

December

January · July

February · August

March · September

April · October

May · November

June · December

Here are six popular greetings in sets of three. The first set is written in simple italic. After you feel comfortable with the basic letterforms, move on to set two with alternate letters and swash capitals, and then you may just want to experience the robust embellishments of set three. Have fun with the flourishes but remember that there is "elegance in simplicity."

You're Invited

Season's Greetings

Happy Birthday

You're Invited

Season's Greetings

Happy Birthday

Congratulations

Best Wishes

Thank You

Congratulations

Best Wishes

Thank You

You're Invited

Season's Greetings

Happy Birthday

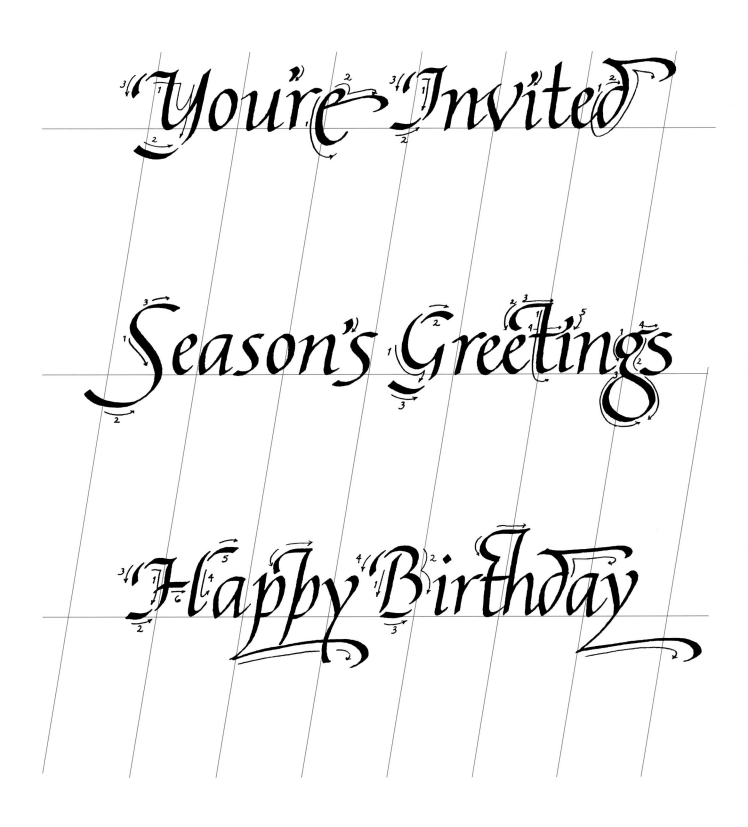

"You're" Invited

Season's Greetings

"Happy Birthday

Congratulations

Best Wishes

Thank You

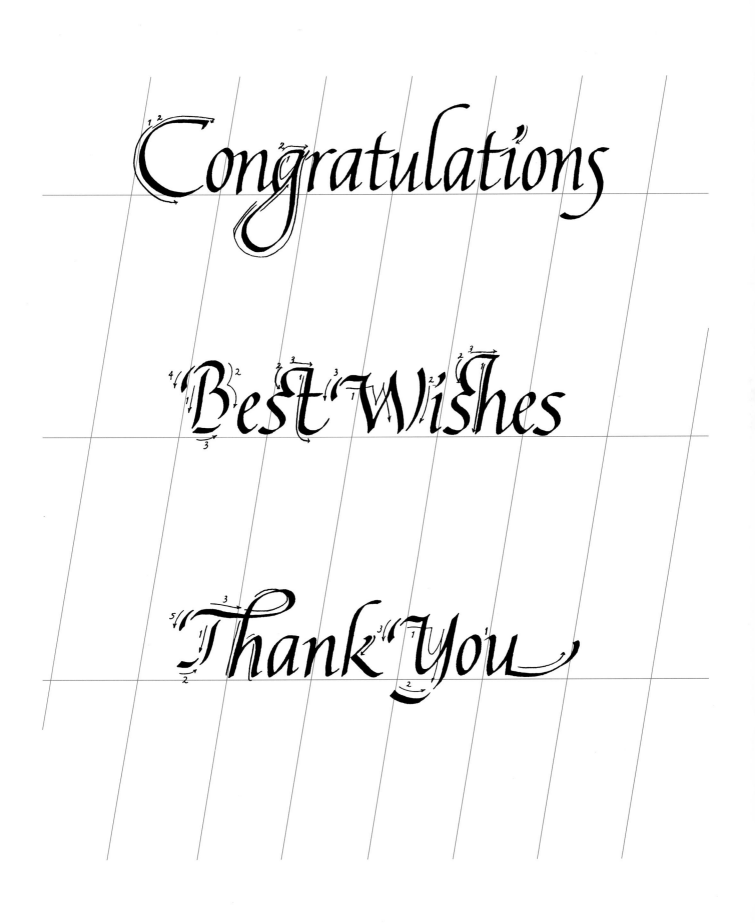

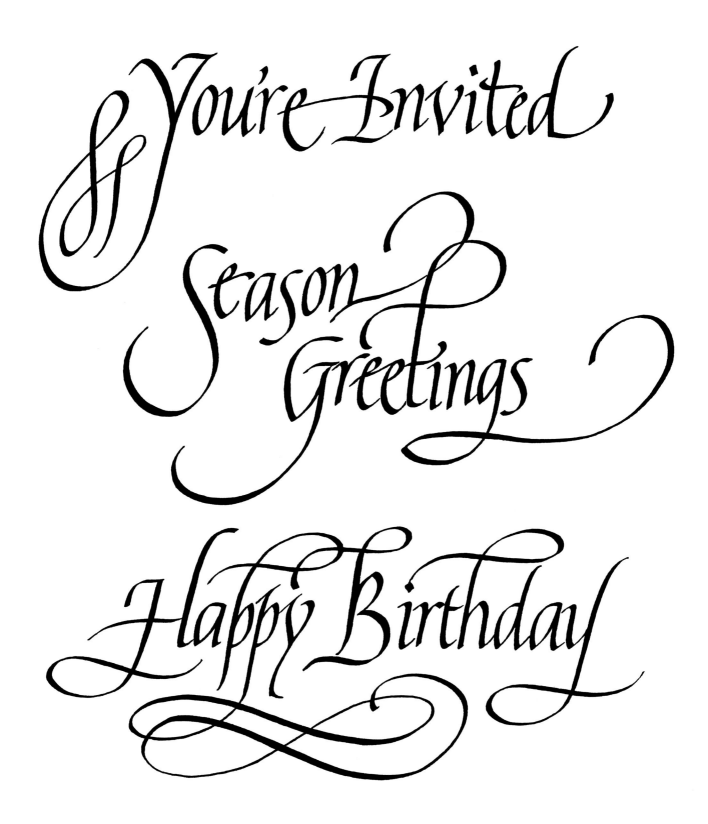

You're Invited

Season
Greetings

Happy Birthday

90

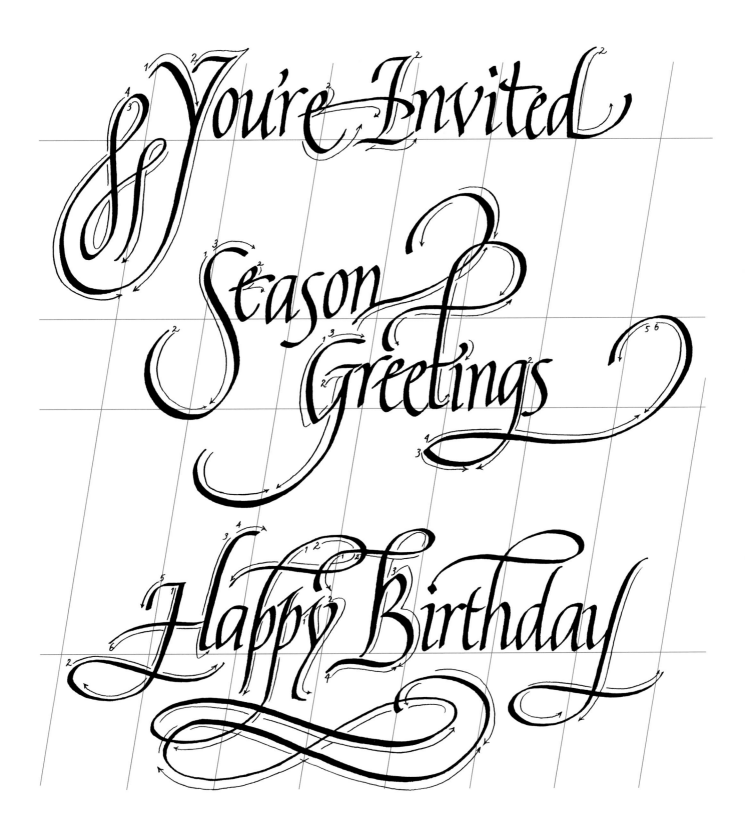

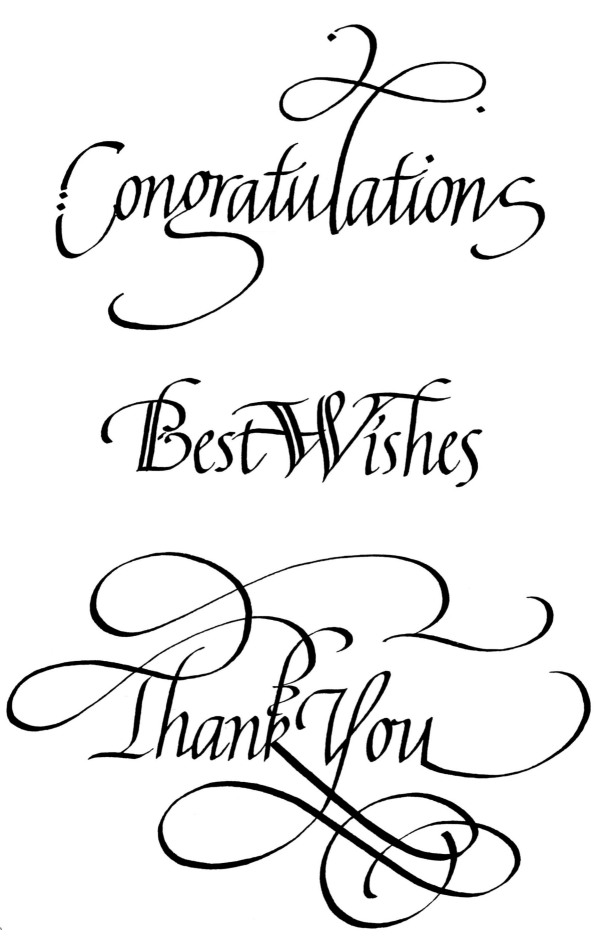

Congratulations

Best Wishes

Thank You

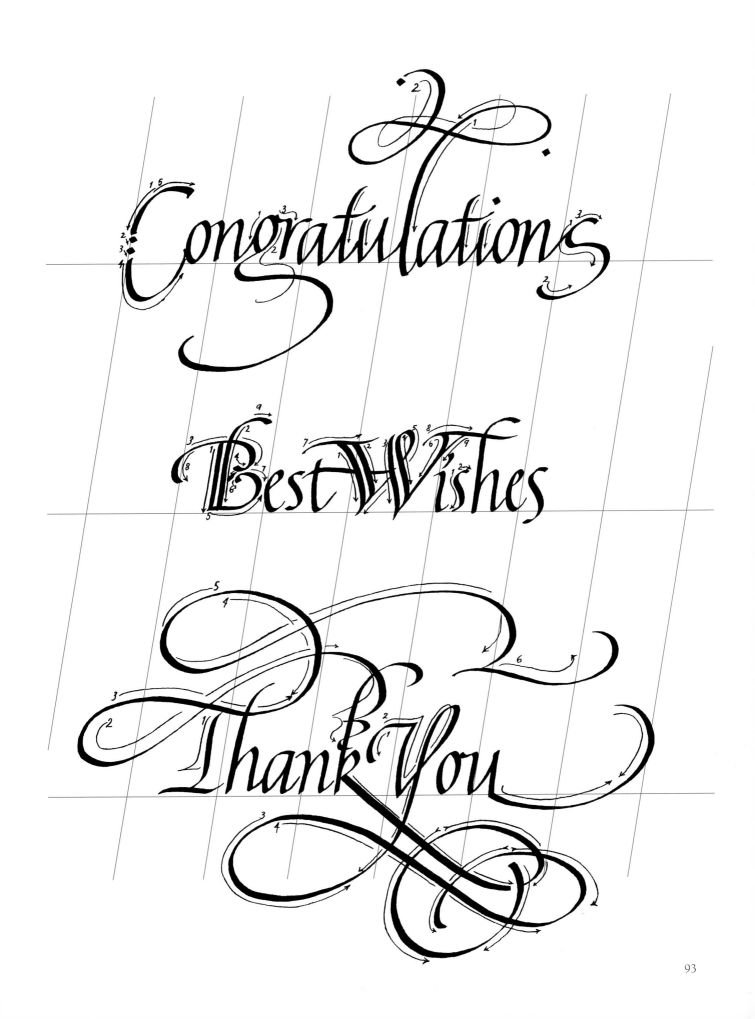

The true calligrapher does not just write words; their very penmanship illustrates the meaning of the words they write. This is accomplished through style and technique or, as this project shows, how the words are separated into lines. The decorative flower is one modeled from the work of Edward Johnston in his classic *Writing and Illuminating and* *Lettering.* It, too, adds life to "The Garden."

This simple quote was written with the C-3 nib.

As is the Gardener, so is the Garden.

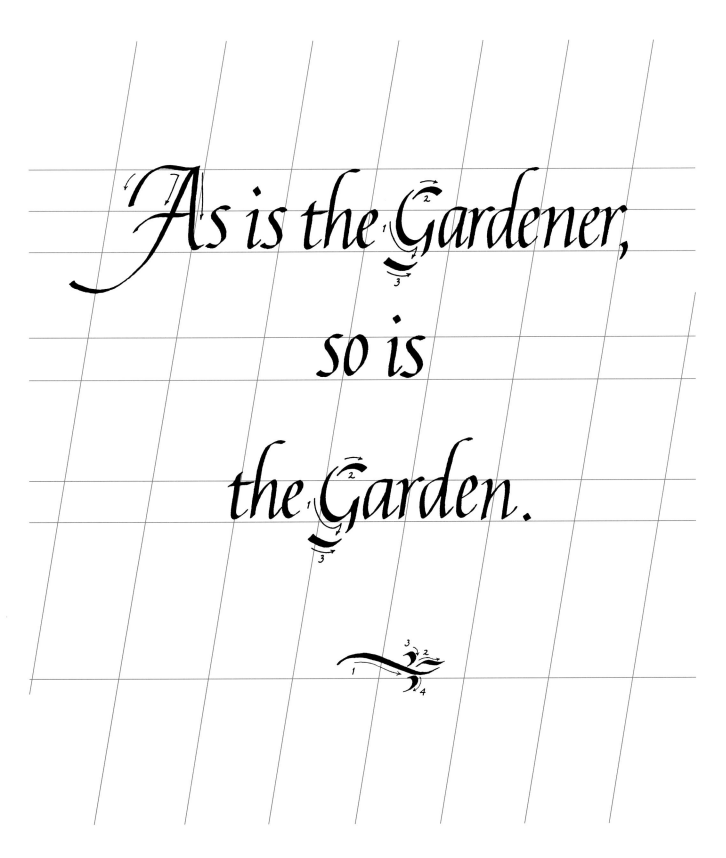

As is the Gardener,

so is

the Garden.

Project Five
RHYTHM AND SPACING

Continuing the organic theme, these words may be ones you would choose to letter on spice labels or small garden placards. I recommend that you photocopy these pages (enlarge to 133 percent). The letters are grey so that you can actually trace over them with your pen. As you do so, you should feel the rhythm of movement and see the equal spacing between and within letters.

These labels, shown here at a reduced size, were written with a C-3 nib.

Annuals · Allspice · Basil
Bay · Chives · Celery · Curry
Dill · Flower · Fennel · Fern
Herb · Honey · Incense · Ink
Garden · Garlic · Horseradish
Jam · Jelly · Ketchup · Legumes
Lemon · Laughter · Lavender
Mustard · Medicinal · Mint
Nostalgia · Organic · Oregano

Oil · Ointment · Perennials

Potpourris · Parsley · Pepper

Rosemary · Salsa · Seasoning

Sweet · Sour · Sage · Seeds · Tea

Tarragon · Thyme · Vanilla

Vinegar · Wild · Weeds

Yarn · Yarrow · Zingiber

Project Six
FORMAL LAYOUT

One way to center formal layout is to measure the length of each line in order to establish its half-way point.

1. Letter out the information. Your work appears more crisp if you letter and then reduce to size.

2. Measure the line.

3. Cut and position to center. Paste down.

4. Use a light blue pencil to indicate the layout's positioning on the paper stock. Blue does not photo-copy. Your work is now prepared for print reproduction.

This formal layout for reproduction was written with a C-3 nib.

Mr. and Mrs. Parents of the Bride request the honour of your presence

at the marriage of their daughter Wilby Goodwife to Husband To Be

the day of the Month One thousand, nine hundred and this year

at the eleventh hour Church of Divine Love Heartland, State

request the honour of your presence

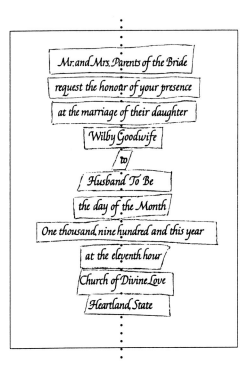

Mr. and Mrs. Parents of the Bride

request the honour of your presence

at the marriage of their daughter

Wilby Goodwife

to

Husband To Be

the day of the Month

One thousand, nine hundred and this year

at the eleventh hour

Church of Divine Love

Heartland, State

Project Seven
ENVELOPE

A beautifully written envelope is a wonderful welcome to a special event. Most likely you will be addressing quite a few at a time, in which case you may not want to consume your time by ruling, penciling and then erasing lines.

Prepared guidelines are helpful. You may also want to consider the use of a light table in order to see those lines through the layer of paper.

1. Design the guidesheet to accommodate the pen sizeappropriate for the size of the envelope.

2. Mark a register for proper placement of the envelope upon the guidesheet. You can lay your envelope on a line, catch the guidesheet securely in the flap, or place it securely in the envelope, which is time consuming.

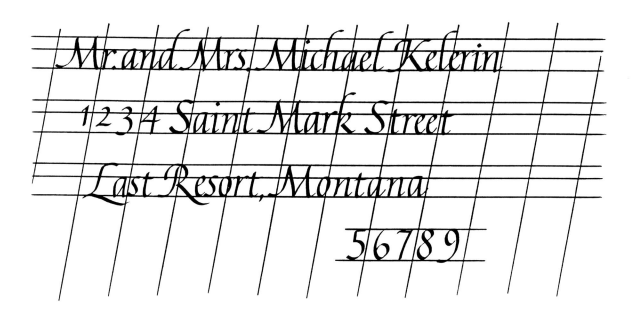

LOVE
USA
1995

Mr. and Mrs. Michael Kelerin
1234 Saint Mark Street
Last Resort, Montana
56789

Trivia

What is the most frequent letter to start a word?
 S, followed by C, then P at about 10 percent of our words.

Trivia

Why is a diploma called a sheep skin?
 Because diplomas were originally done on vellum, an animal skin writing surface often obtained from sheep.

Project Eight
NAME TAGS

Italic is an attractive choice for name badges because it is friendly, artistic, and most importantly, readable. If you are lettering a party's worth of name tags, you may want to use a guidesheet and light table. Write the name as large as will fit the size of the badge. (No one wants to be caught straining to read a name tag, you know.)

You can write the name in two lines to allow it to be larger, but be careful to avoid descender-ascender collisions. It is desirable to keep the two-line name as close together as possible and centered on the badge.

The smallest writing you may ever pen could be upon a placecard. Again, if you are lettering more than a few, you may want to make use of a guidesheet and light table.

Positioning the length of a name to accommodate the length of the card is an obvious dilemma. One way to size up a name is by searching and writing out the longest name on the list, then use that example to gauge the other names in comparison. It is better to begin farther left; if the name is not balanced, you still have the option of adding a swash to fill up the empty space.

JONATHAN LIVINGSTON
STERLING SILVER
LUCY BALL
CORDELIA GREENE

JONATHAN LIVINGSTON
STERLING SILVER
LUCY BALL
CORDELIA GREENE

Jonathan Livingston

Jonathan Livingston

Jonathan Livingston

The name must be easily identifiable to serve the purpose of the placecard. Another placecard dilemma is the "Mr. and Mrs." which could consume half of the card. Be creative to conserve space.

Mr. and Mrs. Jonathan Livingston

Mr. & Mrs. Jonathan Livingston

Mr. and Mrs. Jonathan Livingston

Mr. and Mrs. Jonathan Livingston

Project Ten
SIMPLE POSTER

Like name badges and placecards, which must be readily recognizable, the poster must be readable at a glance. Your first objective is to attract attention and then provide information: the *what, when* and *where.* Keep your lettering large and simple. Try the larger nibs suggested in this book.

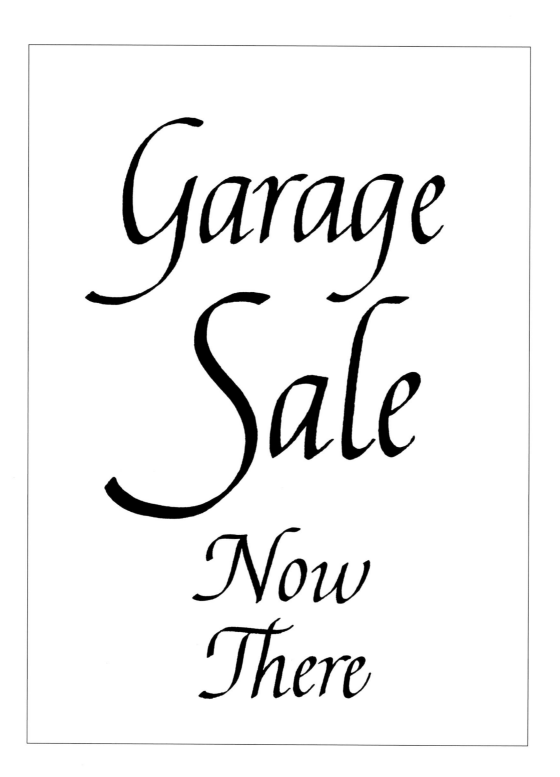

Because a flyer can be held in the hand of the reader, more information can be made available. A flyer is effective if it beckons the attention of the reader and compels him to read it. You may want to review the instructions on layout and page design in chapter three.

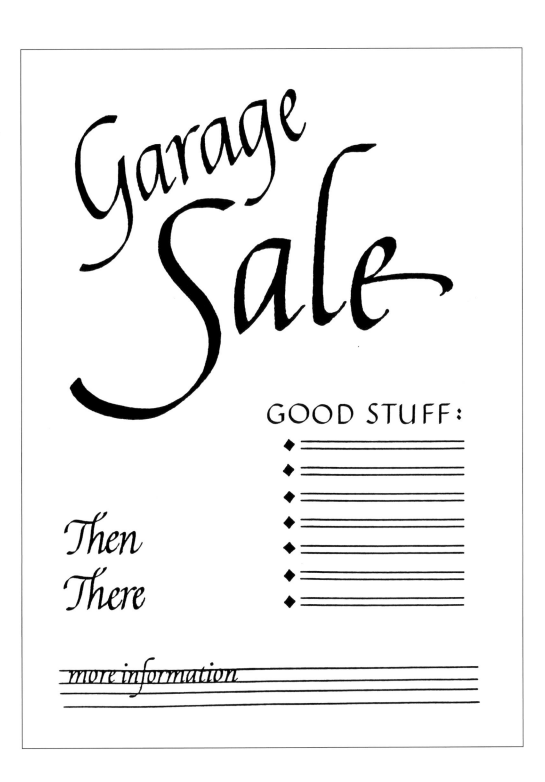

QUOTE—VARYING NIB SIZE

There are simple ways to create attractive layout. These two pages provide a visual comparison of lettering written with one nib versus one written with two different size nibs. The larger letters emphasize the words of importance.

Yesterday
is history.

Tomorrow
is a mystery.

Today
is a gift

--that is why they call it

"the present."

Yesterday is history.
Tomorrow is a mystery.
Today is a gift
-- that is why they call it
"the present".

QUOTE—USING FLOURISHES

Flourishes are fun and add drama to your lettering. If thoughtfully planned, these embellishments add emphasis and can enhance the meaning of the words. Note how effectively two simple flourishes change the appearance of the page and give life to the words.

If you love something set it free.
If it comes back to you it's yours.
If it does not it never was.

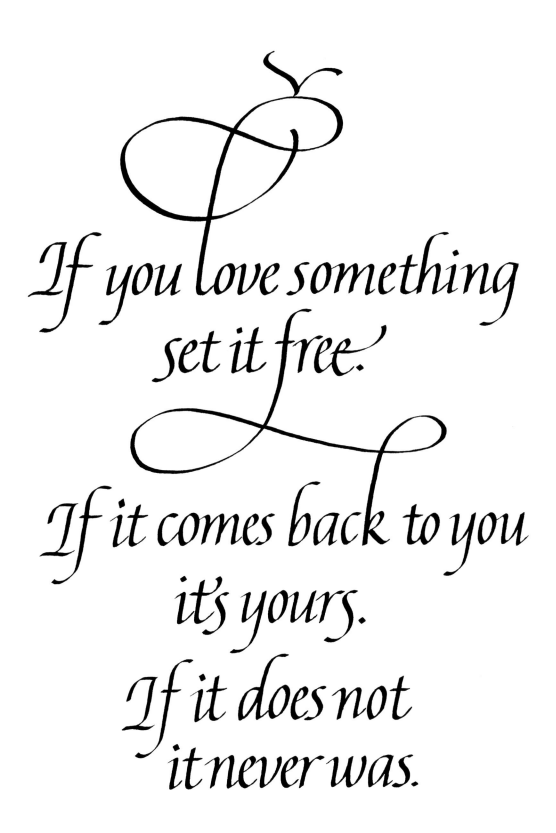

If you love something
set it free.

If it comes back to you
it's yours.
If it does not
it never was.

Project Fourteen
LENGTHY QUOTE

You can break up the monotony of a large block of text by using different layouts. As shown in project twelve, particular words can be emphasized to state their importance; this can be achieved by writing them larger. Note that the work is attributed to Ralph Waldo Emerson; however, his name is written smaller than the text. The space surrounding his name affords the author due respect.

This version is written in shorter lines, which naturally lengthens the poem. Drama is created by the wide margins surrounding the text. It is actually the space where letters are *not* written that emphasizes the importance and creates a reverence for the written word.

To laugh often and much;
to win the respect of intelligent people
and the affection of children;
to earn the appreciation of honest critics
and endure the betrayal of false friends;
to appreciate beauty;
to find the best in others;
to leave the world a bit better
whether by a healthy child,
a garden patch
or a redeemed social condition;
to know even one life has breathed easier
because you lived.
This is to have success.

Ralph Waldo Emerson

To laugh often
and much;
to win the respect
of intelligent people
and the affection
of children;
to earn the appreciation
of honest critics
and endure the betrayal
of false friends;
to appreciate beauty;
to find the best in others;
to leave the world
a bit better
whether by a healthy
child,
a garden patch
or a redeemed
social condition;
to know even one life
has breathed easier
because you lived.
This is to have success.

Ralph Waldo Emerson

To laugh often and much;
to win the respect of intelligent people
and the affection of children;
to earn the appreciation of honest critics
and endure the betrayal of false friends;
to appreciate beauty;
to find the best in others;
to leave the world a bit better
whether by a healthy child,
a garden patch or
a redeemed social condition;
to know even one life has breathed easier
because you lived.
This is to have success.

This is to have success.

COLOR—REVERSAL

Black ink on white paper is always a good contrast, but look at the difference when the letters are white on a black background, as created by this photostat reversal.

I hope these projects encourage you to begin experimenting. Play with color. Dip your pen into different writing fluids and letter on dark and medium-colored paper. The intriguing, often unexpected results will show you how to create fresh expressions and inspire you to seek new and exciting discoveries with the letterforms you have learned to write so carefully.

the great artist is the simplifier

amiel

the great artist is the simplifier

amiel

Alphabet Sentences

Alphabet sentences, also known as "pangrams" and when used to teach or practice an alphabet may be referred to as an 'abcedarium,' is a good way to practice any calligraphic hand. A pangram is a sensible or fanciful statement rendered as briefly as possible using all twenty-six letters of the alphabet, A through Z.

So your practices remain fun and interesting, here is a small collection you may want to use, or if you enjoy puzzles, you may enjoy the challenge of coming up with your own.

The quick brown fox jumps over the lazy dog.

Pack my box with five dozen lacquer jugs.

Brawny gods just flocked up to quiz and vex him.

The wizard jumped quickly over seven green boxes.

Dave quickly spotted four women dozing in the jury box.

John quickly extemporized five tow bags.

Farmer jack realized that big yellow quilts were expensive.

Jay began removing six dozen black quilts with petty flaws.

John P. Brady gave me a fine black walnut box of quite small size.

Brown jars prevented the mixture from freezing too quickly.

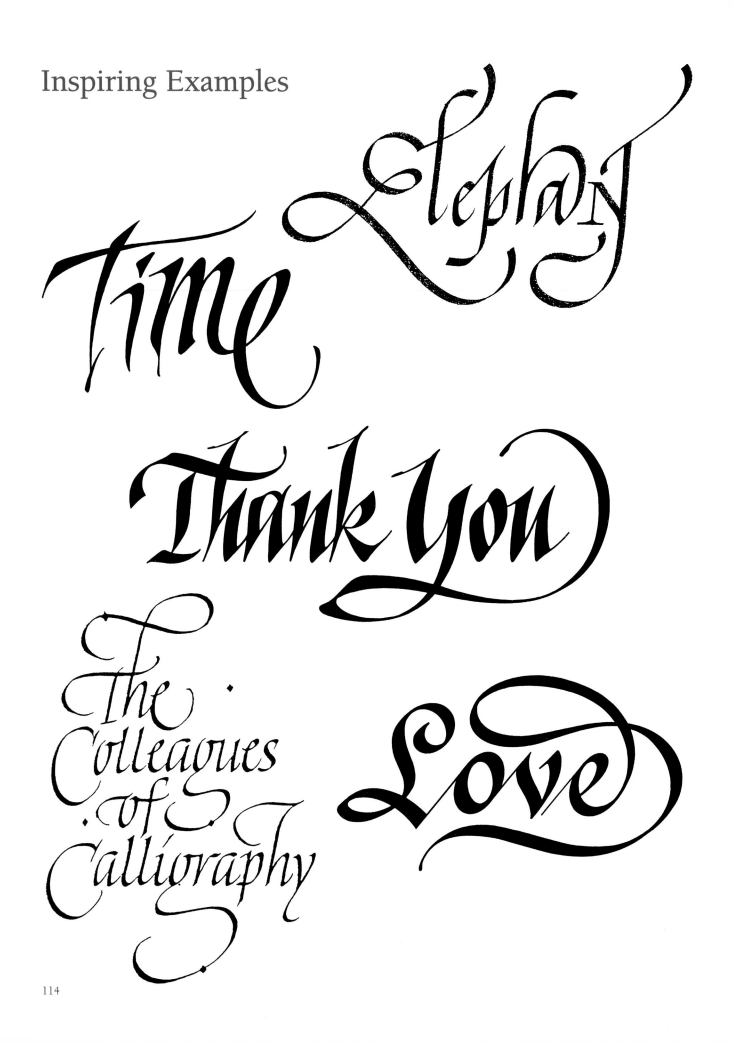

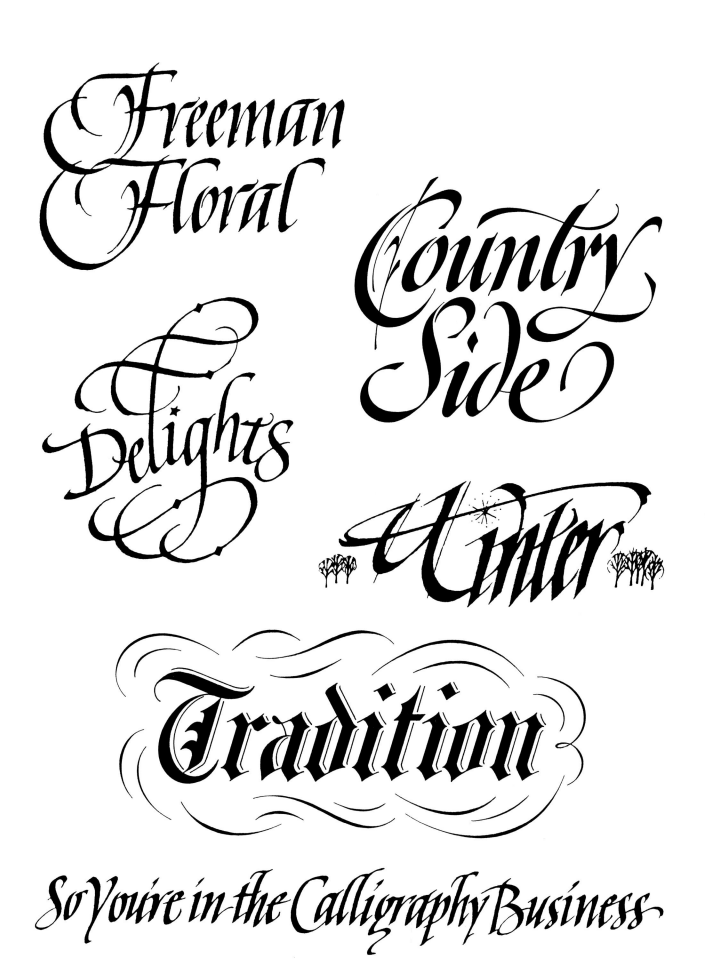

Freeman Floral

Country Side

& Delights

Winter

Tradition

So You're in the Calligraphy Business

Ruled for: Brause 2.5mm•Mitchell 1 ½•Speedball C-2

Ruled for: Brause 2mm• Mitchell 2•Speedball C-3

Ruled for: Brause 1mm•Mitchell 3•Speedball C-5

Recommended Reading

For the beginner:

The Little Manual of Calligraphy
Charles Pearce
Taplinger, 1981

Pen Lettering
Ann Camp
Taplinger, 1984

Written Letters: Thirty-three Alphabets for Calligraphers
Jacqueline Svaren
Taplinger, 1986

Also:

Italic Calligraphy and Handwriting Exercises
Lloyd J. Reynolds
Taplinger

Calligraphic Lettering With a Wide Pen and Brush
Ralph Douglas
Watson-Guptill, 1967

An Italic Calligraphy Hand Book
Carolyn Knudsen
Stemmer House, 1985

Calligraphy for the Beginner
Tom Gourdie
Taplinger

For the advanced student:

Writing and Illuminating and Lettering
Edward Johnston
Dover

The Calligrapher's Handbook
Heather Child
Taplinger, 1986

For historic information:

Masters of the Italic Letter
Kathryn Atkins
Godine, 1988

Three Classics of Italian Calligraphy: The Writing Books of Arrighi, Tagliente, Palatino
Oscar Ogg
Dover, 1953

Books now out of print worth seeking in libraries or used book sources:

The Pens Excellencie
Joyce Irene Whalley
Taplinger, 1980

A Book of Scripts
Alfred Fairbank
Faber, 1977

The First Writing Book
John Howard Benson
Yale University Press, 1954

Sources

John Neal, Bookseller
1833 Spring Garden Street
Greensboro, NC 27403
(919) 272-7604

Paper & Ink Books
15309A Sixes Bridge Road
Emmitsburg, MD 21727
(301) 447-6487

Daniel Smith
4130 First Avenue South
Seattle, WA 98134-2302
(800) 426-7923

Pendragon
PO Box 25036
Woodbury, MN 55125
(612) 739-9093

Dick Blick
PO Box 1267
Galesburg, IL 61402-1267
(800) 447-8192

United Art and Education Supply
Box 9219
Fort Wayne, IN 46899
(800) 322-3247

Glossary

A

Abecedarium: A primer for teaching the alphabet; sometimes in the form of an alphabetic sentence. The name is derived from the first letters of the latin alphabet (a be ce d(e)+ -arium).

Alphabet: Any system of characters, symbols or signs with which a language is written; from the name of the first two letters of the Greek alphabet (alpha-beta).

Alphabet Chain: The letters of the alphabet written with the letter "n" placed between each one (anbncnd, etc.). Especially recommended for the practice of italic writing to establish rhythm and form.

Ampersand: A ligatured form of the Latin word *et,* meaning "and." The ampersand has often been called the twenty-seventh letter of the alphabet. Also called "and sign" or "et sign."

Arch: See "branching."

Ascender: The part of a lowercase letter that rises above its body or x-height.

B

Baseline: The imaginary guideline upon which the bodies of the upper- and lowercase letters sit.

Blackletter: A general term for medieval alphabet styles, so called due to their heavy, black appearance; often very compressed letterforms combined with angular strokes. Also called Text and Gothic; other forms include Old English, Fraktur, Rotunda, et al.

Body (of a letter): The part of any lowercase letter that sits between the baseline and the waistline, i.e., occurring within an alphabet's x-height.

Book Hand: A very general term used to describe any number of various "hands" that have been used for the purpose of producing manuscripts or books.

Branching: This is the part of a character where after the main vertical stroke has been pulled down to the baseline, the pen retraces upward slightly then arcs slightly to the right. This is also called "arching."

Business Hand: A script commonly used for business endeavors or commercial correspondence and chosen for its ability to be rapidly executed and easily read.

C

Cacography: From the Greek, literally meaning "bad handwriting."

Calligraphy: From the Greek, literally meaning "beautiful handwriting."

Cant: To tilt the page to the right or left of vertical relative to the drawing board, e.g., tilting the page to the left is a left cant.

Capital: From the Latin meaning, "head"; the large letters also known as majuscules and uppercase. These letters are the descendants of the classical inscriptional alphabet used by the Romans.

Chancery Cursive: The English version of Cancellaresca Corsivo, the original name for italic writing. This informal cursive script was so named for the Papal Chanceries of the fourteenth century from which it evolved. Also called "Chancery Hand."

Counter: The totally or partially enclosed white space contained within a letterform.

Cursive: Literally means "flowing"; any script written in a continuous, joined fashion without pen lifts or appearing to have been constructed as such.

D

Descender: The part of a lowercase letter that extends below the baseline or x-height.

Display Letters: A general term for large letterforms used for graphic applications such as signage, posters, bookcovers, etc.

Double Pencil: Two pencils fixed together (such as with rubberbands), used to duplicate an edged pen effect in large size. Useful for demonstrating how an edged pen works or creating large letters to be filled in. A kneaded eraser can be used to contrive spacing between pencils.

Ductus: From Latin meaning conducting or leadership; this term refers to information or illustration showing the number, order and direction of strokes that go into making a character (i.e., directions).

Dummy: A mock-up of a page or pages in scale to show placement of all the elements. A working model.

E

Edged Pen: A pen having a thin, wide, truncated writing tip like the edge of a chisel or screwdriver. Also called a chisel nib, broad nib, wide nib, square nib or straight cut pen. (The terms: point, edge, nib and pen are often used interchangeably.)

Engrossing: Originally a term meaning an extremely elaborate hand used for formal documents, but since the mid-seventeenth century, more generally used to describe a style of decorative and usually colorful treatment of letters, words, text and borders on congratulatory, commemorative or memorializing works, such as certificates. See "illumination."

Exemplar: A model character, alphabet or book worthy of copying. Letterforms of a high standard to be emulated.

F

Feathering: The action of ink "bleeding" or spreading on paper producing ragged or erratic edges rather than crisp, sharp forms. This can sometimes be helped by rubbing with sandarac or spraying with a workable fixative.

Flourish: From the Latin meaning "to flower," an unnecessary stroke or element pulled out of or added to a letter for the purpose of ornamentation.

Formal Writing: Letterforms produced with care and accuracy. Usually executed more upright and with pen lifts, often a separate stroke for each element or letter part.

Fugitive Colors: Colors that are not permanent or have a tendency to fade (most often due to exposure to ultraviolet light).

G

Gum Arabic: A water-soluble exudation obtained from acacia trees used as a binder and emulsifier in inks and paints.

H

Hairline: The thinnest possible stroke a pen can make. Also called an "unshaded stroke" or an "edge stroke." With an edged pen, this stroke is created when the pen is moved in the direction of its thinnest edge.

Half Uncial: A hand originating in the fourth century. Uncial but with ascenders and descenders due to certain cursive influences. This hand is often mistaken by beginners to be the lowercase alphabet to the Uncial family; it is not.

Hand: General term for a given style of writing or lettering done by hand.

I

Illumination: A term confused with "engrossing" (see engrossing). Illumination is the decoration of a layout with drawings and/or embellishment and ornamentation of initial letters, words and borders often with color and using burnished gold. Illumination means to bring light into or light up; burnished gold must be used and not just color or decoration to meet this definition.

Informal Writing: Writing done more casually than formal, usually executed more quickly and with minimal pen lifts.

Ink: A fluid used for writing. From the Latin *encaustum* meaning "burnt in." There are many different types of ink.

Interspace: The space between words; also called word spacing.

Intraspace: The space between letters within a word; also called letter spacing.

Italic: Name given to cancellaresca corsivo (chancery cursive) as it was adopted in other countries, due to its origination in Italy.

J

Justified Text: Text where the lines start and finish evenly with the left and right margins.

K

Kern: A part of a letterform projecting beyond the shank or body. Also a typographic term meaning moving pairs of letters either closer together or farther apart.

L

Ladder: A little stack of squares constructed of nib widths used to determine the body height of a letter when using that particular nib.

Layout: A general term for the design of a piece of artwork, usually showing in position all the elements such as margins, headings, text, illustrations, color, etc.

Letter: An alphabetic character. One of the units of an alphabet. A sign, symbol or mark used to represent speech sounds.

Lettering: Differs from calligraphy in that the letterforms in calligraphy are created during the act of writing, whereas in lettering it is more an act of drawing and designing the letterforms.

Letter Space: The spacing between letters, sometimes called intraspacing.

Letterspacing: Refers to adding additional space between letters in a word or sentence; creating gaps between letters, spreading out a word.

Ligature: The connecting of two or more characters into a single form, used mostly for decorative effect.

Lowercase: An old printing term for the small letters or minuscules that has fallen into common usage. So called because printers used to store the small letters in the lower type cases and the caps in the upper case. Abbreviated lc.

M

Majuscules: The formal term for the capitals or uppercase letters.

Manuscript: A book or document written by hand rather than printed.

Margins: The space or border around the outside of a page surrounding the written or printed text.

Minuscules: Formal term for the small or lowercase letters. Usually written within the parameters of our lines; the upper and lower lines being the ascender and descender lines respectively, and the bodies contained between the baseline and waistline.

Monoline: Term describing letters of consistent line weight. No thicks and thins, i.e., without shading.

N

Nib: The writing tip of a pen. Also called a "neb," "bill," "beak" and sometimes "point," even though it's not necessarily pointed.

Nib Width: The width of the writing tip. The thickest shade a pen can produce (with an edged pen) is its nib width. Also called pen width.

O

Oblique: A slanted version of a Roman letter. Obliques are often confused with italics.

P

Pangram: An alphabetic sentence. Can be considered a form of abecedarium.

Parchment: A prepared skin used for the purpose of writing or drawing, usually calf, sheep or goat; however, historically, the skins of many other types of mammals have been used. The parchment most people are familiar with today is a vegetable-based paper made to look like true parchment. See vellum.

Pen: From the Latin *penna* meaning feather, although the first pens were cut from reeds. A tool that holds a fluid for the purpose of writing and/or drawing.

Pen Angle: The angle of the straight, cut-off writing tip of the pen relative to the baseline or horizontal writing lines.

Pen Inclination: The angle of the pen shaft relative to the writing surface.

Pen Lift: Refers to raising the pen from the writing surface after making a stroke, before making the next stroke.

Pen Scale: The relationship of the nib's width to the x-height or body height of the letters. For instance, the x-height of italic is five pen widths; this would make the pen scale one to five.

Pen Slant: Another way of saying pen angle.

Pen Strokes: To make marks with a pen by pulling, pushing or sidling. (A sidled stroke is to move the pen along its thin edge, thus producing a hairline.)

Pen Width: The same as "nib width." The width of the nib of an edged pen at its writing tip. See "nib width."

Print-Script: A simplified version of the Roman letter taught to school children; sometimes referred to as "ball and stick" writing.

Q

Quill Pen: A pen cut from one of the primary feathers of a large bird, such as a goose or turkey.

R

Rag Paper: Rag refers to the cotton or linen content. To say 25 percent rag means that the paper's content is 25 percent cotton or linen; a 100 percent rag paper is made of 100 percent cotton or linen. This type of paper, though expensive, is the most durable of papers.

Reed Pen: A pen fashioned from a reed. This appears to be the oldest form of pen; the Egyptians began using a cut reed about 600 B.C. It was also adopted by the Greeks and Romans as their writing instrument.

Romans: A general term used to describe the category of letter-forms that are based on the classical inscriptional capitals of the Romans; also including the carolingian minuscule, et al., upon which our present day lowercase letters are based. The typographic definition is any upright letter constructed of thick and thin elements (or strokes).

Rotunda: Also called "Southern Gothic" or "Round Gothic" because it was developed and primarily used in Italy, southern France and Spain during the thirteenth through fifteenth centuries. Though not appearing to be quite as heavy as the northern black-letter styles, it is easier to read due to its more open counters produced by its less condensed, rounder form.

Rough: Short for a rough sketch or layout; done quick and loose to show a concept.

S

Sandarac: A resin exuding from the bark of the sandarac tree. In powdered form, used by calligraphers to seal the surface of paper or other surfaces that are too porous, thus inhibiting feathering, bleeding or spreading.

Sans Serif: A letterform not having serifs. Without serifs.

Scriptura Communis: A very formal way of saying "common handwriting," i.e., your everyday handwriting.

Serif: Small finishing strokes on the stems, arms and tails of letters. There are dozens of forms of serifs that have evolved over the centuries. A letter without serifs is called a sans serif letter.

Shading: A term describing the variation in character weight from thick to thin. Shading is produced by the movement of a broad edged pen held at a constant angle or by the variation of pressure with a flexible pointed nib.

Shoulder: The curved stroke of the *h, m* and *n.*

Skew: Refers to the angle of the cut at the tip of a nib when other than square.

Slant: The angle or slope of the letter stems, as measured from the vertical. Also called letter slope or letter angle.

Southern Gothic: A fuller, rounder version of gothic or blackletter stemming from southern Europe, such as "rotunda."

Spacing: The relationship of placement of letter to letter, word to word, and line to line.

Split Pen: A nib with a notch removed from the center of its edge to produce a double line.

Stem: The main vertical stroke or main straight diagonal stroke in a letterform which has no vertical strokes.

Stroke Sequence: The order and the direction of the strokes in which a character is constructed.

Stylus: Any pointed tool used for writing or marking.

Sumi Ink: A Japanese water-based ink made from the carbon soot of burnt pine boughs and roots. This ink traditionally comes in a stick form and must be ground on an ink stone, a *suzuri,* but is available today in a liquid form. An ink prized for its high quality.

Swash: The extension of a stroke or element of a letter for decorative purposes.

U

Uncial: A round style of book hand appearing about the third century, evolving into many variations up through the ninth century. This style of letter is one of the most malleable and is capable of being very playful (pronounced "un-see-al").

Uppercase: Another term for capitals or majuscules; the large letters. So called because printers used to store the capital letters in the upper type cases and the small letters in the lower case. Abbreviated Uc.

V

Vellum: A higher grade of parchment usually taken from younger animals with finer skins. The vellum most people are familiar with today is a vegetable-based paper so called because of its very smooth surface, white translucency and high quality.

Versal: An ornate, "built-up letter" often filled in, sometimes with color; so called because it used to be used in manuscripts to begin a verse in a paragraph, section or chapter.

W

Waistline: Also called the "body line" or "mean line," this is the line that the body of a minuscule letter ascends to.

Writing Lines: The lines used to guide and align the bodies of the letters and their ascenders and descenders during writing.

X

X-Height: The height of the body of a minuscule letter, measured from the baseline to the waistline.

Y

Y-Height: Also called "cap height" or "Z-height," the height of the capital letters; measured from the baseline to the cap line.

Z

Z-Height: Same as "Y-height."

Index

A

Abcedarium 113
Abrasiveness of erasers 15, 17
Acidity of papers 20
Acrylics 17, 21
Alignment 73
Alphabet chain 28
Alphabet sentences 113
Alternate letterforms 48-49
Ampersands 58
Angle of pen 25, 26
Arrighi's caps 57
Art gum eraser 15, 17
Ascenders 27
 Double letters 44
Asymmetrical
 alignment 73
 reference line 72
Automatic poster pen 14

B

Banana husk paper 20
Barrel. *See* holder.
Baseline 27
Bleeding ink 122
Board brush 18
Body line 124
Bracketed serif 58
Branching stroke 28
Brause nibs 10, 12, 13
Broad edge 25
Broad line 24
Broad nib tools 14
Brush. *See* board brush.
Buying nibs 11

C

Calli inks 19
Cap height 27, 124
Capitals. *See* majuscules.
Caps. *See* majuscules.
Centering 72, 73, 75
 project 98-99
Chain, alphabet 28
Character definition 13
Cleaning your tools 11
Clean-up cloth 18
Coit poster pen 14
Cold pressed paper 19
Color
 fugitive 12

mixing 21
 reversal 112
Columns, multiple 74
Compound curve 46
Consistency
 form 31
 pen angle 26
Cost of calligraphy 9
Crossbars
 double letters 44
 italic *t* 47
C-series. *See* Speedball nibs.
Cursive 23
 italic minuscules 60
Curves 46

D

Dead space 70
Deckled edge papers 20
Decorative flower 94, 95
Descenders 27
 double letters 44
 italic *q* 48
Dip pens 10, 15
 gouache 16
 media 17
 nibs 11
 washable inks 20
 watercolor 16
 waterproof inks 19
Double letters 44
Double pencil 25
Drawing board 18, 23
Drawing inks 16
Dr. Martin's Tech ink 19
Ductus 33
 decorative flower 95
 greetings 83, 85, 87, 89, 91, 93
 italic majuscules 53
 italic minuscules 35
 months 81
 simple Roman majuscules 51
 swash greetings 89, 91, 93
 swash majuscules 55
 week days 79
Dummy page 72
Dyes 17
Dynamic layout 72

E

Eberhard Faber markers 12
Edge definition 12, 15, 26

Edge of pen 24
Envelopes 100-101
Erasers 15, 17
Extending lines 75
 swash letterforms 56, 75

F

Faber Castell erasers 15
Feather pen. *See* quill pen.
Filling space 56
Finals 48
Finishes, paper 19
Flag serif 58
Flat pencils 14
Flourishes 108-109
 decorative flower 94, 95
Flush alignment 73
Flyers project 105
Formal italic 23
Formal layout 72, 98-99
Formats 74
Form, consistency 31
Fountain pens 10, 12, 15
 types 16
 washable inks 20
Fugitive color 12
FW inks 19

G

Gouache inks 16-17, 21
Greetings 82-93
Gum arabic 11
Gutter 70

H

Hairline serif 58
Hairline stroke 24
Handles. *See* holder.
Handmade paper 19
Head margin 70
Height of caps 27, 124
Heintze and Blanckertz nibs 13
Higgins inks 19, 20
High finish paper 19
Hiro poster pens 14
Hiro Tape nibs 13
Holders for nibs 11
Holding the pen 23
Hook serif 58
Hot pressed paper 19
Humped shoulder stroke 28

I

Illumination 21
Illustration board 20
India inks 16
Informal layouts 72
Ink eraser 15, 17
Inks
 acrylics 17, 21
 bleeding 122
 drawing 16
 dyes 17
 gouache 16-17, 21
 for illumination 21
 India 16
 non-pigmented 16
 opaque watercolor 17, 21
 pigmented 16
 stain 17
 Sumi 16, 20, 21
 types 16, 19, 20, 21
 washable 16, 20, 21
 watercolor 16-17, 21
 waterproof 16, 19, 21
Ink stone 16
Inner margin 70
Insert box 74
Italic
 basic strokes 29-31
 formal 23
 letterforms 23, 28-31
 majuscules 52, 53
 minuscules 33-43, 46, 47

J

Japanese paper 20
Johnston, Edward 94
 margin ratios 71
Justified alignment 73
Justifying 56

K

Kaligraphia 7
Kneaded eraser 15, 17

L

Layout 72
Letterforms
 alternate 48-49
 italic 28-31
 measuring 27
 swash 56
Ligatured letters 44
Light table 18, 31, 75
Line length 75
Linked g 45
Liquid acrylics 17
Live space 70

Loading the pen 23
Looped g 45
Lowercase. *See* minuscules.

M

Machine-made paper 19
Majuscules
 Arrighi's 57
 italic 52, 53
 simple Roman 50, 51
 swash 54, 55
Margins 70, 71
Marker layout pad 19
Marker layout paper 31
Markers 10, 12, 15
Mean line 124
Measuring letterforms 27
Media 17, 21
Medium finish paper 19
Minuscules
 cursive italic 60
 italic 33-43, 46
Mitchell nibs 10, 13
Mixing colors 21
Mock-up page 72, 75
Mouldmade paper 19
Multiple columns 74

N

Name tags project 102
Nib-ladder 27
Nibs 10, 11, 13
 broad 14
 size chart 12
 varying 106-107
Nonabrasive erasers 17
Non-pigmented inks 16
Numerals 59

O

Ogee curve 46
Old style numerals 59
Opaque media 17, 21
Osmiroid fountain pen 16
Outer margin 70

P

Page parts 70
Page layout 72
Pangrams 113
Papers 19-20, 31
Papyrus 20
Parchment 20
Pelikan
 washable inks 20
 fountain pen 16
Pencils 14, 25

Pens 10, 14, 15
 angle 25, 26
 dip 10, 15
 edge 24
 edge definition 12, 26
 fountain 10, 12, 15, 16, 20
 holding 23
 loading 23
 quill 15
 reed 15, 14
 rolling 26
pH in papers 20
Pigmented inks 16
Pink Pearl eraser 15, 17
Placecards project 103
Plate finish paper 19
Platignum fountain pen 16
Pointed letters 48
Pointed nibs 10
Positioning 103
Poster pens 10, 14
Poster project 104
Posture 23
Practicing the alphabet 113
Preparing nibs 11
Projects
 color reversal 112
 envelopes 100-101
 flyers 105
 formal layout 98-99
 long quotes 110-111
 name tags 102
 placecards 103
 poster 104
 quotations 94-95
 long 110-111
 varying nib size 106-107
 with flourishes 108-109
Proportion formulas 71
Punctuation 59

Q

Quality control 13
Quill pens 14, 15
 waterproof inks 19
Quotations 94-95
 long 110-111
 short 108-109
 varying nib size 106-107

R

Rag content 19
Ragged alignment 72, 73
Recto 70
Reed pens 14, 15
Reference line 72
Reservoir 23
Reversed color 112

Rhythm 96
Rolling the pen 26
Roman majuscules 50, 51
Rotring
 washable ink 20
 fountain pen 16
Rough finish paper 19
Round hand. *See* Mitchell nibs.
Ruled paper 31
Ruled pages 116-119
Ruler 18
Ruling pens 10, 19

S

Sanford markers 12
Sans serif 58
Script space 70
Sentences, alphabet 113
Serifs 58
Shaded stroke 24
Sheaffer fountain pen 16
Shoulder 28
Sizing 20
Slab serif 58
Slab serif Roman 57
Smooth finish paper 19
Spacing 96, 122
Speedball
 dense black India ink 19
 markers 12
 nibs 10, 13
Stains 17
Static layout 72
Stem 28, 47
Stone. *See* ink stone.
Storing tools 18
Strokes
 basic 29-31
 branching 28
 hairline 24
 humped shoulder 28
 shaded 24
Sumi inks 16, 20, 21
Suzuri. *See* ink stone.
Swash letterforms 56
 Arrighi's caps 57
 in greetings 88-93
 looped *g* 45
 majuscules 54, 55

T

Technical pens 19
Three-column format 74
Three-column grid 74
Thumbnail sketches 72
Tick serif 58
Tools
 board brush 18

 cleaning 11
 clean-up rags 18
 drawing board 18
 erasers 15, 17
 light table 18, 31
 lint-free cloth 18
 pencils 14, 25
 storing 18
 straight edge 18
 See also nibs, papers, pens.
Training the eye 7
Transparent media 17
Tree bark paper 20
Triangle 18
 italic *t* 47
T-square 18
Two-column format 74

U

Unit ratios 71
Uppercase. *See* majuscules.

V

Verso 70
Vertical reference line 72

W

Washable inks 16, 20
Watercolor board 20
Watercolor inks 16-17, 21
Waterproof inks 16, 19
Wedged serif 58
White eraser 15, 17
Word spacing 122
Writing position 23

X

X-height 27

Z

Zig markers 12

Get the best art instruction and inspiration available!

This completely revised and updated edition of a popular North Light classic will help you reach greater levels of creativity, inspiration and artistic fulfillment. Inside you'll find over 60 fun activities for achieving new creative heights. Perfect for a wide range of styles and mediums, this book combines practical advice with inspiring exercises and insights from other artists making it the ultimate creativity guide!

ISBN-13: 978-1-58180-756-1, concealed spiral, 176 pages, #33423
ISBN-10: 1-58180-756-2, concealed spiral, 176 pages, #33423

Bert Dodson's successful method of "teaching anyone who can hold a pencil" how to draw has made this tome one of the most popular, best-selling art books in history—an essential reference for every artist's library. Inside you'll find a complete system for developing drawing skills, include 48 practice exercises, reviews, and self-evaluations.

ISBN-13: 978-0-89134-337-0, paperback, 224 pages, #30220
ISBN-10: 0-89134-337-7, paperback, 224 pages, #30220

Create your own artist's journal and capture those fleeting moments of inspiration and beauty! Erin O'Toole's friendly, fun-to-read advice makes getting started easy. You'll learn how to observe and record what you see, compose images that come alive with color and movement, and make a travel kit for creating art anywhere, at any time.

ISBN-13: 978-1-58180-170-5, hardcover, 128 pages, #31921
ISBN-10: 1-58180-170-X, hardcover, 128 pages, #31921

This book shows you how to develop the skills you need to express yourself no matter what unusual approach your creations call for! Experiment with and explore your favorite medium through dozens of step-by-step mini demos. No matter what your level of skill, *Celebrate Your Creative Self* can help make your artistic dreams a reality!

ISBN-13: 978-1-58180-102-6, hardcover, 144 pages, #31790
ISBN-10: 1-58180-102-5, hardcover, 144 pages, #31790

These books and other fine North Light titles are available from your local art & craft retailer, bookstore, or online supplier.